Women Who Read Are Dangerous

WOMEN WHO READ ARE DANGEROUS

STEFAN BOLLMANN

Foreword by Karen Joy Fowler

—

Abbeville Press Publishers

New York London

Translated from the German by Christine Shuttleworth

For the Abbeville Press edition
Editor: Nicole Lanctot
Production manager: Louise Kurtz
Cover design: Misha Beletsky
Interior design: Julia Sedykh

This edition first published in the United States of America in 2016
by Abbeville Press, 116 West 23rd Street, New York, NY 10011

This book was first published in German by Elisabeth Sandmann
Verlag, Munich, under the title *Frauen, die lesen, sind gefährlich*
(2005). It was subsequently published in English by Merrell
Publishers, London, under the titles *Women Reading* (2006) and
Women Who Read Are Dangerous (2008).

First edition
10 9 8 7 6 5 4

ISBN 978-0-7892-1256-6

Library of Congress Cataloging-in-Publication Data

Names: Bollmann, Stefan, 1958- author.
Title: Women who read are dangerous/Stefan Bollman;
foreword by Karen Joy Fowler.
Other titles: Frauen, die lesen, sind gefhahrlich. English
Description: New York : Abbeville Press, 2016. | Includes
bibliographical references and index.
Identifiers: LCCN 2015045513 | ISBN 9780789212566 (hardback)
Subjects: LCSH: Women in art. | Reading in art. | Women—Books
and reading—History. | BISAC: ART / Subjects & Themes /
Human Figure.
Classification: LCC N7632 .B6513 2016 | DDC 704/.042--dc23 LC
record available at http://lccn.loc.gov/2015045513

Contents

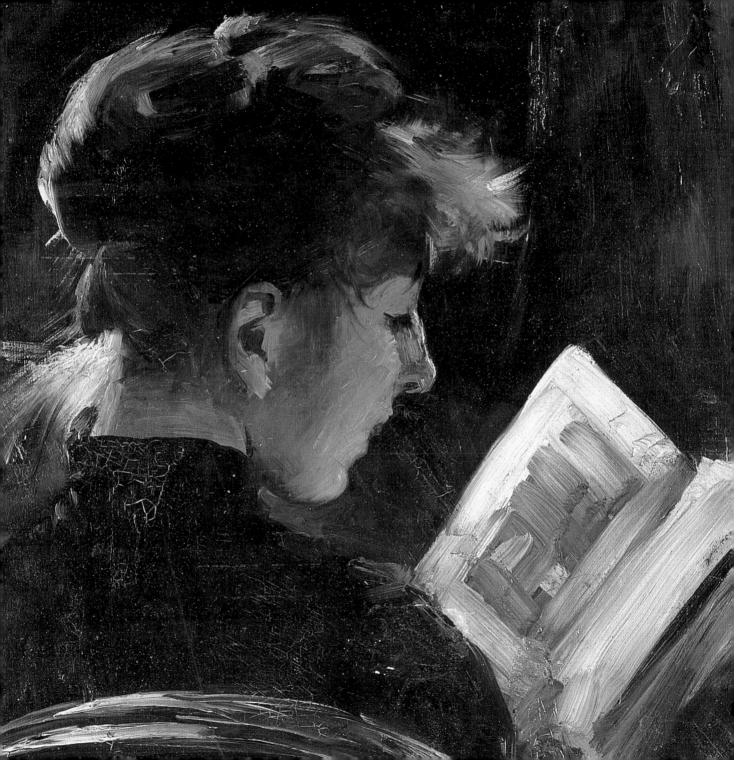

Foreword

Karen Joy Fowler

Vittorio Matteo Corcos
Dreams, 1896

We women who read should take a moment, put down the book, this or any other, look around us. We are experiencing a rare period of triumph. A collection such as this one encourages the long view, reminding us that this triumph has been a long time coming—hard-fought, hard-won. We should note it, enjoy it fast before books disappear entirely, as we've been told (but do not believe) they soon will in favor of digital technologies—shoot-'em-up web games, Internet quests, blogs, and other entertainments that haven't yet been invented.

The woman who reads has a complicated history. When reading is associated with piety and chastity, it has generally been approved. The reading woman's predecessors may be Pandora and Eve, but when Mary stands in a shaft of sunlight holding a book, that book represents purity and prayer, or, in the hands of some other saint, study and discipline (and maybe the privilege of leisure). The literate Virgin is an ideal reader reading an ideal text. She has no plans for public discourse; we need not fear she will take to preaching; she's content with her seclusion. Saints, even the female ones, are safe with the written word. It's the rest of us who've caused so much concern over so many years.

One might wonder why artists so often choose a woman reading as the subject of a painting or photograph. Given the limited access to literacy women have historically had, women readers would seem to be overrepresented in the visual arts. But the image is an interestingly complicated one. We, the viewers, are invited to enter visually, mentally, a place we do not occupy—a garden, perhaps, or a sunlit room—in order to watch a woman

Duncan Grant
The Stove, Fitzroy Square, 1936

who is visually, mentally, in yet another place. She might be time traveling—back to ancient Rome, forward to colonized Mars.

She might, while the book lasts, be a completely different person from the one we are seeing. She might be a man; this is all too likely. She might be a horse and at the very moment we look at her, she might despair, finding herself sold at auction, sent to the glue factory. She might be a rabbit. She might be a hobbit.

She might be having trouble concentrating, or she might be spellbound. She might be escaping from boredom into a frothy romantic comedy. She might be reading a Russian novel, a Japanese, assuring herself that others have also had their troubles. She might be pitting her wits against a world-famous detective. She might just need a good cry. Or she might be experiencing some transformation so profound that she will never be quite the same again. At the very moment we see her, the scales might be falling from her eyes.

What's really going on, then, the important part of the picture, remains invisible. We will never know where or who she is while reading merely by looking. (By this formulation, there is no obvious reason why a man and his book would be a less interesting subject. There are lots of less obvious reasons. He remains a less common choice.)

The image of the woman reading is located at the intersection of two lines that would appear to have no intersection. Emily Dickinson's "There is no Frigate like a Book / To take us Lands away," is one of those lines. The other is Thomas Newkirk's recent characterization of books as "instruments of immobilization." The woman reader is perfectly still, pinned into place and completely unaware of us watching her. Simultaneously, she has escaped us entirely. Probably it's the voyeurism that interests some artists. For others, let's hope it's the escape.

Certainly, historically, the possibility of a woman with a secret life has raised alarm. On the one hand, on the plus side, as long as she is reading, she is not gossiping. She is not idle. She is not indulging in lewd thoughts.

On the other, she is the very picture of idleness! Dinner is not being made. The dishes are not being washed. She is not indulging in lewd thoughts unless she is reading the sort of book—such as Ovid's *Metamorphoses*—that provokes them.

Should women be permitted to have secret lives? Should they be permitted, even within the confines of their own imaginations, to be unchaste? Can they be allowed to imagine themselves as men? Is reading, in its inextricable essence, a combative act, the woman so engaged being temporarily self-interested and independent rather than other-directed in an appropriately womanly way? The problem has occupied some of the best (and worst) of male and female minds.

In 1523 the Spanish humanist Juan Luis Vives proposed careful male surveillance. "The woman ought not to follow her own judgment," he said, as she had so little of it. She should read only what men deemed proper and wholesome. He marveled that any father, any husband, would allow his daughter, his wife to read freely.

Some fifty years later, Edward Hake wrote that the woman who loved frivolous books would "smell of naughtiness even all her life after."

By the Victorian period, mothers had been added to the list of those trusted to choose a daughter's books. Sarah Stickney Ellis suggested that a mother should always be consulted, adding, "It is scarcely possible to imagine a prudent and judicious mother allowing the unrestrained and private reading of Shakespeare among her children . . . it is possible to imagine her reading passages of Shakespeare to her family in such a manner, as to improve the taste of those around her, and to raise their estimate of what is great and good."

For, without this aesthetic elevation, the problem is not only that women might be ruined by reading, but also that reading might be ruined by women. This latter prospect is the specter Samuel Johnson raised when, in discussing the work of Alexander Pope, he said, "too many appeals are made to the ladies, and the ease which is so carefully preserved is sometimes the ease of a trifler. Every art has its terms and every kind of instruction its proper style; the gravity of common critics may be tedious, but is less despicable than childish merriment."

Some critics argued that women were impatient readers, focused only on the story and unable to appreciate the exalted sentiments of the great writers. They were concerned that writers would simplify and sensationalize in order to court them. Others said that what women longed for was sentiment and didacticism. These critics worried that the female aesthetic would impose a stultifying morality over the pleasures of the galloping masculine narrative.

Théodore Roussel
The Reading Girl, 1886–87

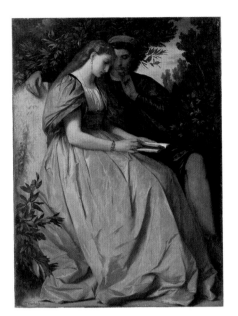

Anselm Feuerbach
Paolo and Francesca, 1864

Rafts of books of conduct have been published, targeted directly at the female readership. These are books women might read in order to learn what books women might read. "There is a long and crowded road," Sandra M. Gilbert and Susan Gubar note, "from *The Booke of Curtesye* to the columns of Dear Abby." Yet, "I have often observed how little young ladies are interested by books of a serious stamp, though written solely for their benefit," Mr. Collins says in Jane Austen's *Pride and Prejudice*. "It amazes me, I confess;—for certainly, there can be nothing so advantageous to them as instruction."

To recap, revise, revamp, and otherwise sum up: Reading makes women better wives and mothers, except when it makes them discontented, idle, or rebellious. Female servants are improved, their minds enlarged by literature, unless they become sulky reading about the romances and possessions of the very rich. Christian women find their faith strengthened by serious reading, unless the complications of the great novels undermine their sense of God in his heaven, all right with the world.

Women are too literal-minded for reading. Women are too sentimental, too empathetic, too distractable for reading. Women are passive, practically somnolent, consumers of popular culture, never realizing how, with the very books they choose, they participate in their own subordination.

Centuries upon centuries of hubbub. Yet through it all women have read on—the unacceptable books as well as the acceptable, Gothic novels in the time of Austen, Harlequin romances, horror novels, space operas, mysteries, police procedurals, chick lit, biographies, and whatever-you-have in our own. Now they are joining book clubs, discussing the nuances of plots and characters and language, sharing their pleasures, their disappointments with other readers. If women's literature is still a category with a slight sneer attached (as of course it is), women are reading not only that, but everything else as well. Suddenly the crisis is not that women read, but that men don't.

The realization that not just the majority, but the vast majority of readers are women—more than eighty percent by some accounts—has resulted in a flurry of articles about boys who listen less well than girls, fidget more, learn to read with more difficulty, think more slowly, value reading less, and, by high school, describe themselves as nonreaders. "Are Boys the

Weaker Sex?" Anna Mulrine asks in an article in *U.S. News & World Report* (an article read, one assumes, then, mostly by women).

In the introduction to *Boys and Literacy*, Elizabeth Knowles and Martha Smith write: "A surprising amount of research has appeared in the last five years about boys and what is happening to them academically at school, especially in the area of literacy. The research is continuing into the university and graduate school years and even drawing from current brain research. The situation appears to be serious."

And what now must be done? Educators are encouraged to include graphic novels in their curricula, fun facts, bathroom humor, fearless and aggressive protagonists, plenty of pictures, plenty of superheroes, quests and monsters (though what girl doesn't like a book with those?), and not so many pesky words. One key ingredient is a father who reads, but apparently there aren't enough of those to go around.

All this scrutiny, all this societal concern is, no doubt, very unpleasant for the boys. For us girls, it's a vacation from the admonishing, the advising, the monitoring to which we are accustomed. We must enjoy this time as such. Soon, someone somewhere will notice that the problem can be solved not by getting boys to read more, but by getting girls to read less, and we will find ourselves right back where we used to find ourselves.

For now, for as long as the vacation lasts, I have my own image of the female reader. She is young and in her own bed. Her parents allow a certain amount of bedtime reading, but all too soon her mother or father will come to turn the light out, tell her that it's time to sleep. The door will be left open when the parent leaves to ensure the light stays off. The girl will wait until she hears her parents' voices in another room, knows they are occupied with other matters. Then she will make a cave under the blankets, open her book inside the cave.

This girl knows the value of a good flashlight; she learned that from Nancy Drew. She will read until she falls asleep, and neither her parents nor anyone else will ever be the wiser. ✎

Women Who Read Are Dangerous

AN INTRODUCTION

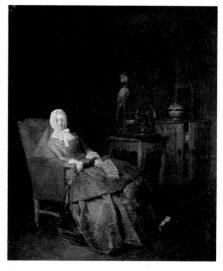

Jean-Siméon Chardin
The Pleasures of Domestic Life, 1746

Reading gives us pleasure and can transport us to other worlds—no one who has ever lost track of time and place while immersed in a book will argue with that. But the idea that reading should give us pleasure, indeed that this is its main purpose, is relatively new; it was loosely established in the seventeenth century and then took root more strongly in the eighteenth.

In the mid-eighteenth century the French artist Jean-Siméon Chardin painted a picture that we know today as *The Pleasures of Domestic Life*. The French title, *Les Amusements de la vie privée*, more precisely refers to the amusements or leisure (rather than pleasures) of private life. For the opposite of "amusement" is not sorrow (the opposite of pleasure), but boredom.

Chardin's picture shows a woman sitting comfortably in a large red high-backed chair, a soft cushion behind her, and her feet resting on a footstool. Chardin's contemporaries believed they could detect a certain air of nonchalance in the woman's fashionable clothing, and particularly in the way she holds the book in her left hand on her lap.

In the background of the painting we observe a small table with a spinning wheel as well as a tureen and a mirror; these two objects are on a cupboard the half-open door of which suggests the presence of more books. But these attributes of domestic life, which do not all suggest pleasure, are unobtrusive by comparison with the bright, colorful appearance of the woman reader in the foreground. Although this woman, who may at other times be found spinning or preparing soup, is holding the book open a crack in order to mark her place, she has not been interrupted while reading—perhaps by her husband demanding his meal or the children their

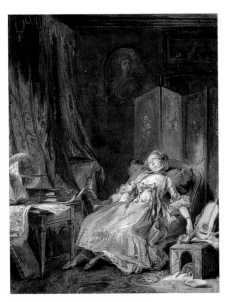

Pierre-Antoine Baudouin
The Reader, c. 1760

scarves and caps, or simply by an inner voice calling her to her chores. Rather, she has interrupted her reading voluntarily, in order to think about what she has read. Her gaze, focused on nothing—not even on the viewer of the painting, who is thus returned to his or her own thoughts— suggests freely floating attention, a reflected inwardness. The woman is dreamily continuing what she has read in her mind and pondering on it. Not only is she reading, she is also making her own image of the world.

Some fifteen years later, Pierre-Antoine Baudouin, a Parisian like his contemporary Chardin, painted another woman who finds pleasure in reading. Baudouin was the favorite painter of the Marquise de Pompadour, who is seen on page 61 in her boudoir in the famous painting by his teacher and father-in-law, François Boucher: She too is reading, though without being absorbed in her book; reclining on a luxurious bed, but ready to go out, and ready if need be to receive the king.

Baudouin's reader, on the other hand, gives the impression that she wants no one to enter her chamber, enclosed by the canopy of her bed and the screen, unless it be the lover of her dreams, conjured up by the gentle narcosis of her reading. The book has slipped out of her hand to join the other objects of female pleasure, the lapdog and the lute. The philosopher Rousseau, referring to this kind of reading, spoke of books that are read with only one hand; here, the woman's right hand, which has slipped under her skirt as she lies enraptured in her chair, her bodice undone, makes it clear what he meant by this. On the table on the left are folios and maps strewn in confusion, one of which bears the title *Histoire de voyage* (Story of Travel), as well as a globe. Whether these indicate a husband or lover far away, who will return one day, or simply the heedlessness with which learning is here sacrificed to sensual pleasure, remains an open question.

Although Baudouin's image is decidedly more frivolous and direct than Chardin's portrayal of the pleasures of reading, it might also seem far more moralistic: Like so many paintings of its era as well as later ones, it warns against the corrupting influence of reading. But in this case, this is mere pretense. In reality, Baudouin is playing with morality, and using it as a diversionary tactic. While showing a woman overcome by her sensual reveries in a lascivious pose, he is addressing an increasingly hypocritical clientele, which, as Baudouin's contemporary critic Diderot perceptively observed, consisted of "little abbés, light-minded young lawyers, portly financiers, and other people of bad taste." The woman seduced by her read-

ing matter must meanwhile take the blame, even though it is not so much her own view of the world that is in question as that of her observers, who are all too willing to be captivated by a little dissoluteness.

DANGEROUS READING

Other societies played with morality in this way too, but they also took it extremely seriously. When the rage for reading began to take hold in the days of Chardin and Baudouin, first in Paris, then in other parts of the world, everyone, particularly women, carried a book in his or her pocket. This phenomenon, so disturbing to some contemporaries, rapidly gained supporters as well as critics. The former encouraged "useful" reading, which would channel "reading mania," as it was known, toward virtuous and educational material. Their conservative opponents saw in unrestrained reading further evidence of the inexorable decline in manners and social order. The Swiss bookseller Johann Georg Heinzmann, for example, regarded the excessive reading of novels as the second extreme phenomenon of the age after the French Revolution, claiming it had brought as much misfortune to people and families "in secret" as the "terrible Revolution" had done in public. Even the proponents of the Enlightenment believed that unrestrained reading was damaging to society. The results of "tasteless and thoughtless reading," according to the philosopher Johann Adam Bergk in 1799, were "senseless extravagance, insurmountable reluctance to undertake any effort, boundless love of luxury, suppression of the voice of conscience, becoming tired of life, and an early death"—in short, a reversion from bourgeois virtues to aristocratic vices, which would be punished by the diminution of life expectancy. "The lack of all physical movement while reading, combined with the forcible alternation of imagination and emotion," said the teacher Karl G. Bauer in 1791, would lead to "slackness, mucous congestion, flatulence, and constipation of the inner organs, which, as is well known, particularly in the female sex, actually affects the sexual parts"—so anyone who read a great deal and whose powers of imagination were stimulated by reading would also be inclined to masturbation, as indeed we can already observe in Baudouin's painting.

But such moralizing could not hold up the triumphal march of reading, including—and specifically—female reading. This essentially had to do with the fact that the love of reading that gripped both Europe and North

America from the seventeenth to the nineteenth century was not a revolution in the real sense, as was long believed. The change in reading behavior must be seen in the context of the three great upheavals in the development of modern societies, as observed by American sociologist Talcott Parsons. These were industrialization, democratization, and a revolution in education—a wave of literacy that encompassed all levels of the populace, and the continual extension of the period of education, which today often extends well into the third decade of life. Yet all three processes, which naturally contributed to the development of reading behavior, only hastened and completed a tendency within the evolution of reading that asserted itself over a far longer period.

SILENT READING

Today we might ask what the bone of contention was that so enraged moralists about the phenomenon of intensive and excessive reading. A clue can be found in the phrase "in secret," quoted above, used by the bookseller Heinzmann when he lectured on the "plague of literature." For "in secret" not only means private, and thus not public, it also means not subject to the surveillance of society, including the most immediate society—the community of family, house, or religion. This loss of surveillance, which from a more positive perspective signifies an intimate, familiar relationship between book and reader, was made possible by the practice of silent reading.

We take silent reading for granted, but it was by no means always common practice. To encounter perplexity at such behavior we must go back even further than the seventeenth or eighteenth century. The classic example is found in St. Augustine, who was so amazed by the reading behavior of Bishop Ambrose of Milan that he entrusted the experience to his *Confessions*, written toward the end of the fourth century. On his (usually unannounced) visits to the bishop, he would find him "silently immersed in reading," for Ambrose never read aloud. Augustine reports that, while reading, Ambrose's eyes glided over the pages, and he traced the sense in his heart. But his voice was silent, and his tongue was at rest. Augustine gives us several explanations for such strange behavior on the part of this busy man whom he admired so much. Two of these have to do with the shortage of time remaining to Ambrose for mental relaxation.

Does he wish not to be distracted during these brief moments, Augustine asks, or not to have to enter into discussions with other listeners? In fact, silent reading saves time compared with reading aloud. And the reader is allowed an undisturbed relationship with his reading matter, which he is able to conceal from others and make his exclusive property.

An illiterate today is not only someone who cannot read (or write), but also anyone who cannot understand a text unless he or she reads it aloud. Yet there must have been a time when the opposite was the case—when reading aloud was the norm, as silent reading is today. Classical antiquity certainly knew the internalization of the reading voice, but this way of reading was fairly rare. Just as today we are surprised if someone utters sounds while reading, and we inwardly seek reasons for this, the same must have happened in the past when someone did not read out loud. Until well into the Middle Ages and in some cases well into modern times, reading consisted of both thinking and speaking, and was above all an act that took place not in separation from the outside world, but at its center, within the social group and under its surveillance.

The emancipation of silent reading from reading aloud first took place among monastic scribes, and was only later transferred to university and educated aristocratic circles, spreading very gradually, with the progress of literacy, to other groups of the population. The tomb of Eleanor of Aquitaine shows the queen, who died in 1204, lying on the lid of her sarcophagus as though on a bed, holding an open book in both hands. Silent reading, we learn from this astonishing tomb, could be considered a symbol of heavenly joys, particularly in the case of a woman who had distinguished herself in her lifetime as a patron of the arts and literature, and who spent the last years of her life in a convent; certainly, it was by no means associated with earthly pleasure.

Even the direct relationship of the individual with God, propagated by the German priest and scholar Martin Luther in the sixteenth century, could be cited with reference to silent reading. But even Luther, whose criticism of certain Church practices led to the Protestant Reformation, acknowledged the inherent risks in allowing people to read and interpret the word of God for themselves. Not until the end of the seventeenth century, and particularly with the rise of pietism, which focused entirely on the devoutness of the individual, did the private study of the Bible become the duty of all believers. The campaign for literacy mounted by the

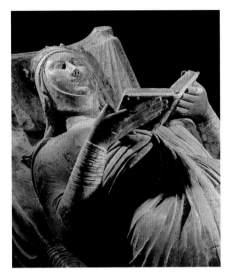

Tomb of Eleanor of Aquitaine, c. 1204

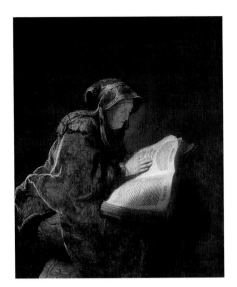

Rembrandt van Rijn
*An Old Woman Reading, Probably
the Prophetess Hannah*, 1631

Swedish Lutheran Church between 1686 and 1720, with the support of the government, has become famous. Not only did the acquisition of reading skill become an official condition of membership of the Church, but also inspectors combed the land to test the state of knowledge. However, the populace, now so proficient at reading, used their new skill not only to demonstrate their knowledge of the catechism, but also to gain practical knowledge. Women, in particular, acquired elementary knowledge of hygiene and the care of infants with the help of a booklet distributed by the health authorities, and as a late consequence of the reading campaign, the high infant mortality rate was considerably lowered in the following decades. With more children surviving the first years of life, women needed to bring fewer children into the world, which gave them more time that they could use, for example, for silent reading. The fact that Sweden is today the model progressive state may have had its origin here.

With the ability to read, however, there developed new patterns of private behavior that were to threaten the legitimacy of both the Church and secular authorities on a permanent basis. Women who learned to read at that time were considered dangerous. For the woman who reads acquires a space to which she and no one else has access, and together with this she develops an independent sense of self-esteem; furthermore, she creates her own view of the world that does not necessarily correspond with that conveyed by tradition, or with that of men. All this does not yet signify the liberation of women from patriarchal guardianship, but it does push open the door that leads to freedom.

WOMEN'S READING

In 1631 Rembrandt painted an old woman reading (the picture is often known as *Rembrandt's Mother*, though some see the figure as the prophetess Hannah). The massive book on the old woman's lap, seemingly emitting a light of its own, is recognizable as the Old Testament, partly because of its Hebraic lettering. The woman's wrinkled hand lies flat on the open page, in the way that older people who have trouble reading often mark the line they are about to read. But the gesture is also the expression of the intense relationship of Rembrandt's reader with the words of the Bible; it is as though she wants to take the significance of what she is reading deep into her inner self.

It is not only this security of faith that encounters a crisis with the coming of the Enlightenment and the increased spread of silent reading; in addition, books—or perhaps just this one—sacrifice their unconditional authority. No longer do they proclaim unquestioned truth, but increasingly become instruments that serve the self-awareness and self-interpretation of their readers, both male and female. At the same time, these readers stop falling back on the same books again and again, those passed on from generation to generation. Instead, they make themselves masters of new, not necessarily religious, reading matter that conveys to them empirical knowledge, critical ideas, and aspirations that until now had lain outside their grasp. In Protestant northern Europe such tendencies, even though repressed, had already been visible for some time. Dutch seventeenth-century paintings also provide eloquent evidence of this. In no other European country at that time could so many citizens read and write as in the Netherlands, and nowhere else were so many books published. Travelers reported that by the mid-sixteenth century literacy had already reached peasants and the working population. Among women, skill in reading was more widespread than skill in writing, which would remain a male domain for some time to come. A painting by the Dutch artist Pieter Janssens Elinga, created in the 1660s, shows a servant girl engrossed in reading a book. Unlike Rembrandt's old woman reading, she has her back turned to us—a traditional sign of estrangement from the world. But her state of contemplation is by no means directed at the word of God. An indiscreet glance over her shoulder at the open book, to which the painter invites the viewer, allowed contemporaries to recognize without doubt what kind of book has claimed the reader's attention: It is "the beautiful story of the knight Malegis, who won the famous horse Baiart, and undertook many wonderful adventures"—the Dutch version of a medieval heroic epic, which was one of the knightly romances that were extremely popular at that time. A few of the painting's details suggest that the artist is criticizing the woman's reading habits as frivolous and improper. For example, the fruit bowl seems to have been set aside in unthinking haste and now threatens to slip at any moment from the rounded upholstery of the chair by the wall; the cushion, which was actually intended for the chair that the reader has drawn closer to the three upper windows for the better light, has apparently been thrown carelessly on to the floor. The slippers, which probably belong to the mistress of the house, are lying untidily in

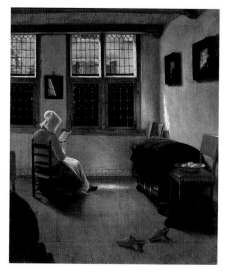

Pieter Janssens Elinga
Woman Reading, 1668–70

the middle of the room; in her burning wish to resume her reading as soon as possible, the servant girl has probably stumbled over them. Thus we gain the impression that the girl is using the absence of her mistress to indulge her passion for reading, rather than diligently pursuing her household duties, as Calvinistic ethics would have required. When the mistress is away, domestic order seems immediately to be threatened.

If indeed such order ever existed. For whose is the book containing the adventures of the knight Malegis that has cast such a spell over the servant girl? It probably does not belong to her but to her mistress. This adds to her other transgressions the serious one of having misappropriated the property of her employer. Even if the reader is only "borrowing" the book, she probably has done so without asking permission. This circumstance surely casts significant light on the leisure pursuits and the lifestyle of the lady of the house.

ANARCHIC READING

There were two social groups in particular that would in future represent the revolution in reading habits: young intellectual women, and women of means. Both were searching for new texts; but rather than using these texts to assert themselves against the old authorities, they were driven by the need for private and social self-assertion. Both groups had a relatively large amount of free time at their disposal: the young middle-class intellectuals because their prospects were limited in a socially immobile world; the wives and daughters of the bourgeoisie because with growing prosperity they had servants and therefore also free time, or at least intervals scattered throughout the day, that could be used for reading. Even ladies' maids and chambermaids were able to make use of this luxury of additional time; light to read in the dark, which was expensive, was available in employers' households, and sometimes there was even some money left over for the lending library. (Book prices were still exorbitantly high around 1800. For the price of a new novel, a family could be fed for one or two weeks.) In contrast to traditional scholarly and "useful" reading, the new reading habit had something undisciplined and wild about it: It was tailored toward the heightening of the reader's powers of imagination. It was not the time spent reading, reckoned in hours and days, that was important,

but rather the intensity of the emotional experience. Beyond the arousal of individual, specific feelings such as pleasure, grief, or devotion, readers, both male and female, were almost addicted to the feeling of self-worth that reading produced. They longed to experience their own emotional stimulation, for it conveyed to them a new, delightful awareness of themselves, such as could never be provided through the fulfillment of their prescribed roles in society. In their immediate environment such emotion largely remained without an outlet, or quickly encountered resistance. An example is Gustave Flaubert's *Madame Bovary* (1857), in which the writer conveys the intensity of the longing for happiness unleashed by the reading of novels, and also the impossibility of overcoming failure. The books that Emma Bovary reads give her an idea of what experiences life might have to offer, but the demands she then makes on herself and on life cannot be reconciled with reality. It all ends in disaster, with an inevitability that had already long been foreseen in the world of men. New canons were rapidly established, based on what was considered acceptable literature, so that women, whose exuberant powers of imagination are sufficiently well known, should not endanger themselves and their husbands as a result of a pernicious mania for reading.

However, readers, both male and female, soon no longer allowed themselves to be advised, let alone dictated to, on their reading matter, but read whatever came on the market—and there was more and more to read. As to how to read, actual reading habits also overturned traditional ideas of what was proper. Women's reading, in particular, took place unsystematically, absent-mindedly, and often in secret. It fitted in with the day's routine and periods of leisure time, but was also determined by moods, opportunities, caprices, and the fashions of the belles-lettres market.

We can form a picture of the reading day of a "brilliant" and voracious young woman reader at the beginning of the nineteenth century from a letter that Bettina von Arnim, the mistress of imaginary correspondence, wrote to herself in the name of her friend Karoline von Günderode. Von Armin's description of her own room after she had been absent for some considerable time reads like the psychological portrait of a wild reader who travels in wonderful anarchy through all ages, styles, and fields in her choice of reading matter and her reading habits:

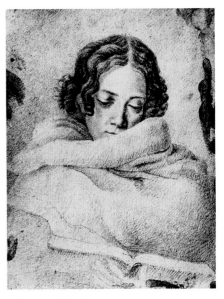

Ludwig Emil Grimm
Bettina von Arnim, 1810

. . . in your room the scene resembled a seashore where a fleet lay stranded. Schlosser wanted to retrieve two large folios that he had lent you from the city library, and which you have already had for three months without reading them. Homer lay open on the floor; your canary had not spared him. Your beautiful imaginary map of Odysseus's travels lay beside him, and the box of shells, with an overturned bowl of sepia and shells of all colors round about, causing a brown stain to appear on your lovely straw rug . . . Your giant reeds by the mirror are still green; I made sure that they had fresh water. Your box with oats, and whatever else has been sown in it, contains a confused mass of growth, which I think includes a great number of weeds, but since I cannot tell the difference, I did not dare to pull up anything. As to books, I found on the floor Ossian, Sacontala, the *Frankfurter Chronik*, the second volume of Hemsterhuis, which I took for myself because I have the first volume from you . . . *Siegwart, A Novel of the Past*, I found on the piano, with the ink-pot lying on top of it; luckily it had only a little ink left in it, but you will hardly be able to decipher your "Moonlight" composition any longer, over which the pot's flood had emptied. Something was flapping about in a little box on the windowsill and I was curious enough to open it, when two butterflies flew out that you had put in as pupae, and Liesbet and I chased them to the balcony, where they satisfied their first hunger among the blossoming bean plants. From under the bed, Liesbet swept out Charles XII and the Bible, and also—a leather glove, which does not belong to any female hand, with a French poem inside it; this glove seems to have been lying under your pillow.

It is not hard to imagine the reading habits of this young lady. The freedom she allowed herself included "leafing back and forth, skipping whole passages, reading sentences back to front, misunderstanding them, remodeling them, extending them, and refurbishing them with all sorts of associations, drawing conclusions from the text of which the text knows nothing, becoming angry at it, being pleased with it, plagiarizing

it, and at any convenient time tossing the book that contains it into the corner." No, these are no longer the phrases of Bettina von Arnim, but were written more than one hundred and fifty years later by Hans Magnus Enzensberger to characterize the "anarchic" act of reading. They describe the status quo of the reading habits of the time. Admittedly, this free, unregulated use of books did not arise all at once, but rather established itself in a long process of opposition to a highly ordered practice, burdened by constraints.

Walter Launt Palmer
Afternoon in the Hammock, 1882

The advocates of orderly reading today are teachers and scholars in the humanities. They seem to be fighting a losing battle, especially in the face of competition between audiovisual media and traditional printed products in the fields of entertainment and information. Since the major liberalization of reading habits between the seventeenth and the nineteenth century, anyone is free to decide not only what and how, but also where to read. Now anything goes: preferably at home, lounging in an armchair, in bed, or lying on the floor, but also in the open air, on the beach, or while traveling by train or bus. As early as the mid-eighteenth century, a German traveler reported from Paris on the countless opportunities for reading: on the promenade, at the theater, in the café, in the bath, in stores while waiting for customers, on Sunday, sitting on a bench outside the front door, or even while going for a walk. The act of gazing silently at the pages of a book created an atmosphere of intimacy that separated the reader from his immediate surroundings and yet allowed him to stay at the center of them (as young people and joggers have been doing for some time with music); in the midst of the city's bustle and in the presence of others, the reader could remain undisturbed in his own company.

Today, especially during a meal, people sitting alone often arm themselves with exciting reading matter against the conspicuousness of their solitary state. A few readers, as in the past, prefer the reading rooms of libraries, where people still read in the same position as they once did, at the student's lectern, sitting upright, the book lying in front of them, their arms on the table, in total concentration on the content, and if possible without causing any disturbing sounds. The library is a good place to be alone and yet in human company, in the midst of a community of kindred spirits, where each person is occupied with something that concerns him or her exclusively.

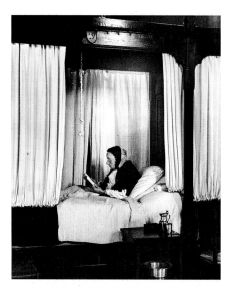

André Kertész
Hospice de Beaune, 1929

READING IN BED

Even if there is no longer a privileged place for reading, there are favorite possibilities for retreat that fit in with an unbridled and carefree way of life. One of these is bed, which has already played a prominent role in the description of Bettina von Arnim's room. As a sleeping-place sought out night after night, which also serves as a place for lovemaking and dying, in which people are conceived and born, to which they retire when ill, and where they quite often draw their last breath, bed takes up a position of almost inconceivable importance in human life. Over the last centuries it has increasingly become a showplace for human intimacy. Since the mid-eighteenth century more and more paintings have depicted reading in bed as a new, typically female habit.

As a young girl the French writer Colette, as she later related in one of her novels, used to argue with her father, a war veteran, about her reading. The problem was not that he forbade her to read certain books; rather, doubts about what passion in books had to do with daily life, and whether certain books should be allowed into children's hands, were expressed by her mother. Her father, on the other hand, took hold of anything printed that happened to be lying around, and took his booty into the cave of his library, where it would disappear, never to be seen again. No wonder the young girl learned at an early age to hide her reading matter from her father. Buried deep in the pillows of her bed, Colette would read the books she had concealed from her father's hands and her mother's eyes. Her bed was her refuge, and reading in bed allowed her to spin a cocoon of security around herself.

Colette was to remain faithful all her life to this place for reading. Everywhere and in all phases of her life she tried to find places and windows in time in which she could be undisturbed, alone with a book. In her final years, as a result of illness, she hardly left her bed, tenderly calling it her "raft." It was in bed that she received visitors, celebrated her eightieth birthday, read, and wrote. The Princesse de Polignac gave her a lectern for this purpose that fitted exactly over her bed.

In 1971 the photographer André Kertész published a book in the United States called *On Reading*. It contains sixty-five black-and-white photographs that with few exceptions show people reading, and includes no text apart from the credits on the last page. Kertész took his photo-

graphs of readers all over the world, in Paris and New York, in Venice, Tokyo, Kyoto, Manila, New Orleans, and Buenos Aires, and in a Trappist monastery. The oldest photo shows three poorly dressed children, covered in filth, two of them barefoot, sitting on the ground in front of a wall and gazing with the greatest concentration at a book held on the knees of the child in the middle. The picture was taken in 1915 in Hungary, where the photographer, born in 1894, grew up as Andor Kertész and taught himself the art of photography. And yet the message of *On Reading* is not that everyone in the world reads everything possible. Certainly, Kertész's readers read in all parts of the world and in all possible and impossible situations, but the reader is always quite a special, discriminating individual. Kertész's camera isolates readers from their surroundings, just as they isolate themselves from them for, and through, the process of reading. In the crowd the reader is the introverted loner, in the mass of other-directed consumers the self-directed idler. Steadfastly he or she stares into a book or newspaper, leaving the viewer with an impression of unassailability.

The best-known photograph in *On Reading*, and the one that closes the series of images, was taken in 1929 in a hospice in Beaune, in the Burgundy region of France. In this perfectly composed image we see an old woman, small and shrunken, sitting up in bed, holding in her hand a book that she is reading attentively. The heavy, dark wooden beams and the light-colored gathered curtains of a bed canopy lend a theatrical air to the scene, as though for a moment of uncertain duration the viewer's eye is allowed a glimpse of a significant drama, at the end of which the curtains will close for good. Of course, it would make a certain difference if instead of, say, a prayer book, the old woman were reading a play by Racine, or even some scandalous novel of the day, but the question of whether we are dealing with a pious, a cultured, or a rebellious reader is not really at the center of what the photograph shows us ("Don't think, look!" is said to have been a favorite saying of Kertész's). And what do we see in the photograph? An old woman in the bed where she will sooner or later die, neither praying nor declaiming nor rebelling, but reading. Reading, in Kertész's pictures, is an existential gesture, one that seems to survive even in the face of imminent death. It is not merely stimulation or a pastime, but has a truth of its own.

"We retreat into ourselves, let our bodies rest, make ourselves unreachable and invisible to the world," writes Alberto Manguel in his *A History*

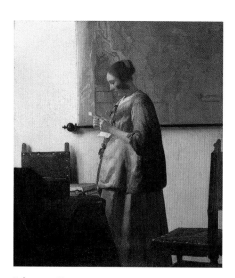

Johannes Vermeer
Woman Reading a Letter, c. 1663–64

of Reading (1996). "*Solitude en hauteur*," sublime solitude, was the name given with a certain irony to this condition by Colette, of whom Kertész made some of his, and her, most impressive portraits.

THE INTIMACY OF READING

Reading is an act of friendly isolation. When we are reading, we make ourselves unapproachable in a tactful way. Perhaps that is exactly what has interested painters for so long in the portrayal of readers: showing people in a state of deepest intimacy not intended for outsiders. If the viewer were to approach the readers in real life, this condition would immediately be threatened. So painting allows us to see what we actually cannot see, or see only at the price of destroying it.

If any painter succeeded in depicting, with the greatest possible intensity and integrity, an intimacy so easily and rapidly injured, it was Vermeer. Many of the pictures he painted in the course of his short life show young women who are totally absorbed in their current occupations or who have just been interrupted in them. These might be everyday activities such as the pouring of a liquid, the weighing of gold, or the trying-on of a necklace; often they have something to do with music; and again and again they concern the reading and writing of (love) letters. Thus we see the pregnant woman in the blue jacket deeply engrossed in the reading of a letter that she has probably received from her husband; the map of southeast Holland on the wall in the background, also seen in other paintings by Vermeer, allows the absent spouse to be present for the viewer too—though in a way that can hardly compete with the depth of feeling with which he is present for the reader of his letter. Her lips are half open, as if she is about to read aloud the words of the letter to herself—a sign of the intensity with which she takes in its content, but perhaps also of the effort it takes her to decipher the letter. As if in a protective covering, this reader shelters in an aura of intimacy that is radiated by the whole painting, as small as it is precise. "Vermeer, that mysterious painter," as the Dutch writer Cees Nooteboom remarks, "had created a rapport with Dutch women, he had magically transformed their sobriety; his women ruled over concealed, closed worlds, which were not to be entered. The letters they read contained the formula for immortality."

Four centuries later, almost nothing seems to be left of this formula. In 1931 the American Edward Hopper painted *Hotel Room*, an almost square painting, comparatively large for him. A woman in her underwear sits on a hotel bed; she has slipped off her shoes and carefully placed her dress over the arm of a green chair behind the bed; she has not yet unpacked her bag and suitcase. The deeply dark, almost completely black space below the yellow roller blind tells us that it is night. The woman, whose features are in shadow, is reading not a letter but a leaflet, presumably a timetable. She seems indecisive, almost baffled, and defenseless. Over the rigid scene hangs the melancholy of railroad stations and anonymous hotel rooms, of being on a journey without arriving, of the arrival that is merely a short stopover before a further departure. Hopper's timetable-reader is as deep in thought as Vermeer's letter-reader, but here this absorption has no object; the reader is existentially homeless, expressing an unease with the modern world. All that remains of the aura of intimacy is a snapshot of life without expression and without location.

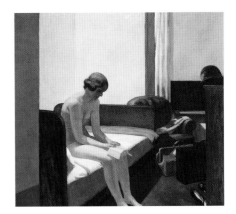

Edward Hopper
Hotel Room, 1931

Hopper's readers are not dangerous, but endangered—less by an unfettered power of imagination than by the modern popular illness, depression. A painting made seven years later shows a similar woman in a train compartment: She too is reading, a leaflet in a larger format. According to these images, an incurable melancholy now lingers over men and women who read, as though the cheerful chaos of reading mania has in the end become as indifferent as the expressions of Hopper's women readers and the printed matter that occupies them without any real engagement.

A conservative and somewhat malicious criticism would attribute the discontent of these women to the fact that they have broken out of the intimacy of their protected spaces and, like men, are wandering around in an increasingly impersonal world, instead of waiting patiently for the return of their loved one, who every so often sends a letter home. This is what they get for it! But there is also evidence of a different, self-assured way of dealing with the situation that shows women as positive and equal to it, instead of mourning for an inwardness that has probably been irretrievably lost.

In 1924, a year before his death, Félix Vallotton, born in Lausanne and working in Paris, painted a semi-nude that he called *Reading Abandoned*. No trace remains of the sultry bedroom atmosphere that centuries earlier

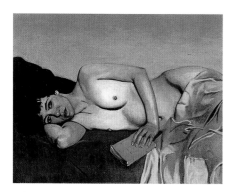

Félix Vallotton
Reading Abandoned, 1924

had been associated with the portrayal of women readers lying undressed in bed. What is recorded here is the moment after reading: The book, laid aside but still tenderly touched by the woman's hand, directs the viewer away from the woman's nakedness toward her expression. Our observations began with the depiction of a similar situation. Chardin also chose to record the moment of time immediately after reading, or following its (freely chosen) interruption. But unlike the reader in *The Pleasures of Domestic Life*, Vallotton's reader seems to be not so much clinging to the thought of what she has been reading as fixing the viewer with her direct gaze.

With this gaze, all reveries are dissolved, whether linked to something read or painted, or whether arising from the intimate relationship between book and reader or between image and viewer. It is up to you, says this gaze: You have the choice. Destiny cannot be read in a book—particularly red books, whether they concern love or politics. There is only the uncertainty of the situation, of which you have as little command as I. We live in the here and now. If you wish to be my equal, argue things out with me. Otherwise, go away and do not disturb my reading.

The following gallery of images of women reading functions as a virtual museum. Leafing back and forward, the reader can stroll around in it, catch glimpses, and make connections. The short commentaries are intended to support this tour. Even images of reading need to be read.

Reading, said the French writer Jean-Paul Sartre, is a free dream. Often we tend to see at first the fabricated dream and less the created act. And yet intensive reading is exactly that—a challenge to our creative freedom. Do we know what to do with this freedom? ◞

Where the Word Lives

BLESSED READERS

Christianity is a religion of the book. In the early Christian era, Christ was depicted with a scroll. The Bible, the "Book of Books," contains histories, texts, and prophetic books. Traditionally, the book is found as a religious symbol in the hands of men: Christ, the Apostles, the saints and martyrs, preachers, monks, patrons, and princes of the Church. It is the vessel of divine grace and the bearer of spiritual authority.

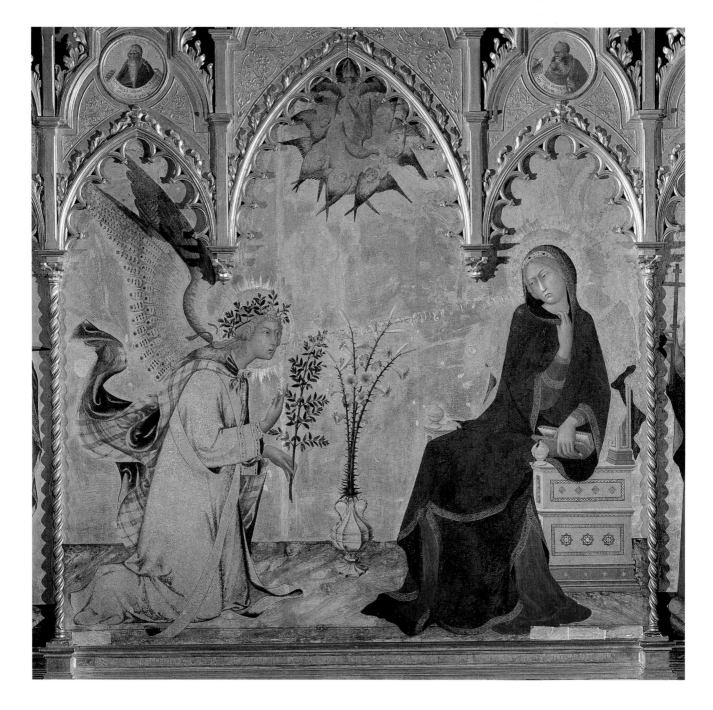

Simone Martini (c. 1284–1344)
Annunciation, 1333
Uffizi, Florence

THE VIRGIN MARY

Simone Martini

By the fourteenth century, representations of the Annunciation were no longer a rarity. But no one had depicted the event quite as the painter Simone Martini of Siena did. The angel's garments and wings are dipped in shining gold. His lips are slightly parted for speech, and what he is saying is inscribed on a banderole that leads toward Mary's ear: "Hail, full of grace, the Lord is with thee. Behold, thou shalt conceive in thy womb. Fear not, Mary."

And what does Mary have to say? Her startled attitude was noticed even by contemporary observers of the painting. It is as though she is seeking refuge in her corner from the power of the angel's words. Her fear has a defensiveness about it, combined with a strange indifference. Almost as if to turn away from the encounter, she pulls her cloak more closely around her breast. The red book that she has been reading, symbol of her wisdom, is held open by her thumb at the place at which she was interrupted by the angel's arrival. The format and design of the book suggest that it is a book of hours. These were used as personal devotional books by wealthy people in the late Middle Ages, and also often served for teaching children to read.

So we also see in this Annunciation the birth of something new. Martini's Mary is a wise woman, no longer the naïve innocent the theologians liked to imagine. She has mastered an art that became the practice of educated women in the late medieval period: silent reading, which enables her to acquire knowledge of her own accord—not through obedience, but through private study. And anyone who is as absorbed in a book as this Mary will be startled if she is disturbed. ☙

Hugo van der Goes (c. 1440–1482)
Portinari Altarpiece, 1476
Uffizi, Florence

SAINTS MARGARET AND MARY MAGDALENE

Hugo van der Goes

Here we see the right-hand panel of an altar painting created by the Ghent master Hugo van der Goes, and commissioned by the Florentine Tommaso Portinari (hence the name the Portinari Altarpiece) for a church in Florence. The triptych, with its mighty proportions (it is twenty feet wide), is among the most impressive testaments in Italy to the old Netherlandish school of painting.

Portinari was director of the Medici banking house in Bruges between 1465 and 1480, and it was there that he commissioned the work. The main panel shows the birth of Jesus, while the two wings portray the Portinari couple with their children. The painter has reverted to the custom, already antiquated by this time, of showing the donors at a smaller size than their patron saints; thus an imperious severity emanates from the figures of saints Margaret and Mary Magdalene, who rise above Portinari's wife, Maria Baroncelli, and her first-born daughter, Margherita.

St. Margaret, dressed in red, holds an open book in her left hand. However, she is not looking at its pages; rather, the book is here simply as a symbol of faith, and, together with the cross, performs the function of a defensive talisman. It is directed against the dragon at the saint's feet, in whose mouth we see one of her slippers. According to legend, the martyr Margaret, when in prison, was visited by the Devil in the shape of a dragon, who tried to attack her and in one version of the story actually devoured her; but Margaret was able to defeat him with the sign of the cross. In Van der Goes's altar painting, the protective effect of the cross is strengthened by the reference to the book of holy scriptures. ❧

Ambrosius Benson (c. 1495–1550)
Mary Magdalene Reading, 1540
Ca' d'Oro, Galleria Franchetti, Venice

MARY MAGDALENE

Ambrosius Benson

The vessel containing ointment that the Mary Magdalene of the Portinari Altarpiece holds in her right hand here stands on a table. It is this attribute in particular that indicates that this young woman reading is another example of an embodiment of holiness.

From the thirteenth century, the figure of Mary Magdalene, the sinner and penitent, enjoyed great popularity. She was identified with the prostitute whose sins were forgiven by Jesus in the house of the Pharisees. Earlier, at least according to the Gospel of St. Luke, she had covered Jesus's feet with tears, then dried them with her hair, and finally kissed and anointed them.

The association of Mary Magdalene with a book does not appear before the fifteenth century. Unlike the attributes of a death's head and mirror, which would be added later, the book does not represent the enticements of worldly life, but on the contrary their conquest by humble contemplation. Soon, however, paintings of Mary Magdalene took her outside the sphere of the Church, and she appeared on canvas again as a beautiful young woman, often lightly clothed or not clothed at all—although frequently with a book in her hand.

Ambrosius Benson, a painter born in northern Italy and at this time active in Bruges as an independent master, often painted allegorical portraits of women in accordance with contemporary taste, including a series of Magdalenes. They were exported as far as Spain and Italy and also sold at the January and May markets in Bruges, where Benson was represented by up to three stalls. For the contemporary observer, this pretty young woman, gazing devoutly at her book covered in red velvet, had the allegorical significance of a promise of marriage. ⟩

Michelangelo Buonarroti (1475–1564)
Cumaean Sibyl, c. 1510
Sistine Chapel, Rome

A CUMAEAN SIBYL

Michelangelo Buonarroti

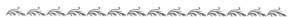

The Renaissance gave new life to the stories and figures of mythology. In his powerful series of frescoes in the Vatican's Sistine Chapel, Michelangelo brought together Old Testament prophets and pagan sibyls.

Sibyls were the prophetesses of Classical antiquity: women who, in a state of ecstasy, foretold mainly terrifying events. Their epithets referred to the places where they were active; thus the Cumaean sibyl is said to have uttered her prophecies in an oracle cave at Cumae, in Italy's Campania region.

Ovid relates that Apollo wanted to bribe this sibyl with gifts in order to seduce her. When she asked him for as many years of life as a hand can contain grains of sand, she forgot to wish that she also remain forever youthful. And so, for most of her thousand years of life, she is a fragile old woman, until in the end her once tall and beautiful figure becomes so tiny and worn that she can no longer be seen by anyone, and only her voice can be recognized.

Michelangelo shows us this sibyl long before this final stage. Her body has already aged considerably and her face is deeply furrowed, but her mighty and muscular arms resemble those of a strong young man.

The most famous story concerning the Cumaean sibyl involves the nine prophetic books that she offered for a high price to Tarquin (Lucius Tarquinius Superbus), the last king of Rome. When he refused to buy them, she burned three of them, and then another three, until Tarquin eventually paid the full original price for the remaining three books. Legend has it that for some centuries they were kept, strictly guarded, in the Temple of Jupiter on the Capitoline Hill, to be consulted in times of emergency. It is in one of these books that Michelangelo's sibyl, half witch, half giantess, is reading our future—yet the pages appear to be blank. ◈

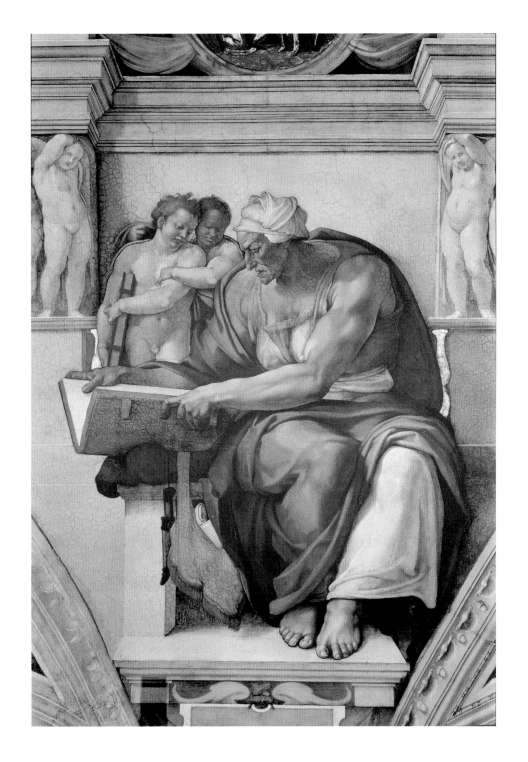

47

Intimate Moments

Quiet time alone was rarely to be had in European societies before the sixteenth century. Reading habits played a great part in the gradual formation of an intimate, private sphere. A woman silently reading enters into a bond with the book that is outside the control of society and the immediate community. She acquires a free space, gaining for herself a sense of independence and self-esteem. And she begins to create her own picture of the world that does not necessarily correspond with that of tradition or of men.

Domenico Fetti (1588/89–1623)
Girl Reading, c. 1620 (attributed to Fetti)
Gallerie dell'Accademia, Venice

A YOUNG ITALIAN GIRL

Domenico Fetti

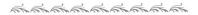

Domenico Fetti, to whom this simple picture of a simple girl is attributed, was a painter of transition: In his hands, mythological scenes and stories of saints turned into genre scenes and achieved a new secularity. Fetti demythologized myth and made religion worldly; he experimented with a precisely detailed, almost naturalistic perception of reality. His paintings show that the representation of a human virtue is not tied to a canon of traditional attributes and symbols, but can be expressed simply by a certain attitude, a certain look, a certain treatment of light.

The highly detailed rendition of the folds in the young woman's cheap clothing gives her appearance a touch of nobility and dignity that places her on a par with people of rank. In the same year, 1620, Fetti painted his famous *Melancholy*. It shows a female figure deep in thought, with a skull before her and her head resting on her hand, meditating on the transitory nature of earthly things. The partially eaten piece of bread at the lower left of the image here is somewhat reminiscent of the skull of *Melancholy*; and just as Fetti's figure of Melancholy was for a long time assumed to be a penitent Mary Magdalene, contemporary observers may also have taken his reading girl as the embodiment of a female penitent. Today, however, what we perceive is the almost indescribable grace of this young reader; she gives us a sense that reading, like Aphrodite's magic girdle, may have the power to lend charm and procure love. ☙

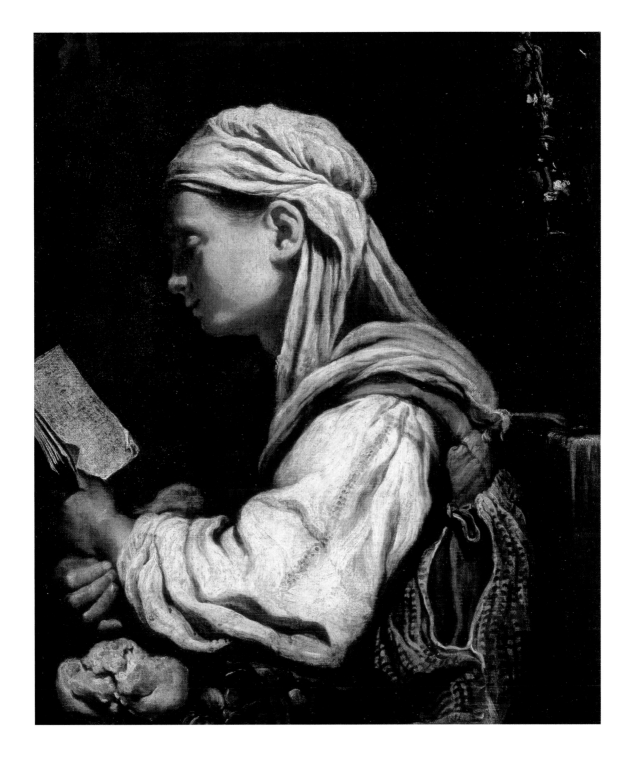

THE PROPHETESS HANNAH

Rembrandt van Rijn

Throughout his life, Rembrandt was preoccupied with old age. Even in his youth he created portraits of old men and women marked by the traces of a long life and increasing frailty. Despite what the popular title of this painting suggests, his model here is certainly not his own mother. Rembrandt's close contemporary Jan Lievens (1607–1674) used the same model for his own painting of an old woman reading, although he placed a pince-nez on her nose. Both women, in accordance with the custom of the day, are reading the Bible. Rembrandt has covered the old woman's entire body in sumptuous material. Only her hand and furrowed face can be seen. The massive Old Testament seems to emit a light of its own, with the wrinkled hand of the woman lying flat on the open page as she attentively studies the text. In this way older people who have difficulty in reading mark the line they are about to read; but the gesture is also an expression of the intimate relationship between reader and text.

Contrary to popular belief, in Classical antiquity old age and the elderly were regarded in a negative light. Old people had fulfilled their function by being active in the state and producing children. Rembrandt's image, however, creates a direct relationship between the dignity of old age and the authority of the text, which records many aged prophets and prophetesses. Nothing could be less superfluous than the respectful study of the Bible; free of other commitments, old people may gain a dignity in such reading. The authority of the book and the inner composure of the old woman correspond to one another, with the woman expressing freedom and retreat from roles and commitments already fulfilled. �

Jacob Ochtervelt (1634–1682)
*The Declaration of Love to the
Woman Reading*, 1670
Staatliche Kunsthalle, Karlsruhe

A YOUNG GERMAN WOMAN AND HER SUITOR

Jacob Ochtervelt

The letter as a form of written communication was very fashionable in the Netherlands in the seventeenth century. In no other European country at that time could so many citizens read and write, and correspondence became increasingly important in economic and political relationships, and also in private and intimate ones. The success of a correspondence depended not only on an appropriate mode of expression, but also on the writing being both legible and aesthetically appealing. Manuals on the art of letter-writing and calligraphic pattern-books came on the market. Soon, letter-writers and letter-readers—more letter-writing men than women, and more letter-reading women than men—began to populate the world of painting. Famous examples are found among the works of Johannes Vermeer, Gerard ter Borch, and Pieter de Hooch.

The painting opposite is part of this milieu, and at the same time transcends it. For it is one of the few images of the time that show media competing with each other—in this case, book, letter, and conversation.

The man seems to be repeating in speech the declaration of love that he has already entrusted to the letter seen lying on the table. The woman is aware of the letter's content, since the red seal has been broken. However, apparently unmoved, she continues to read her book, which at the moment seems to be more important to her than any written, oral, or other form of interaction (note the bed in the background), although she appears to be far from unapproachable. However the story may develop, one thing is clear from this picture: The woman is enjoying the attention bestowed on her, but she refuses to acknowledge this, burying herself in her reading—or at least pretending to do so. ☙

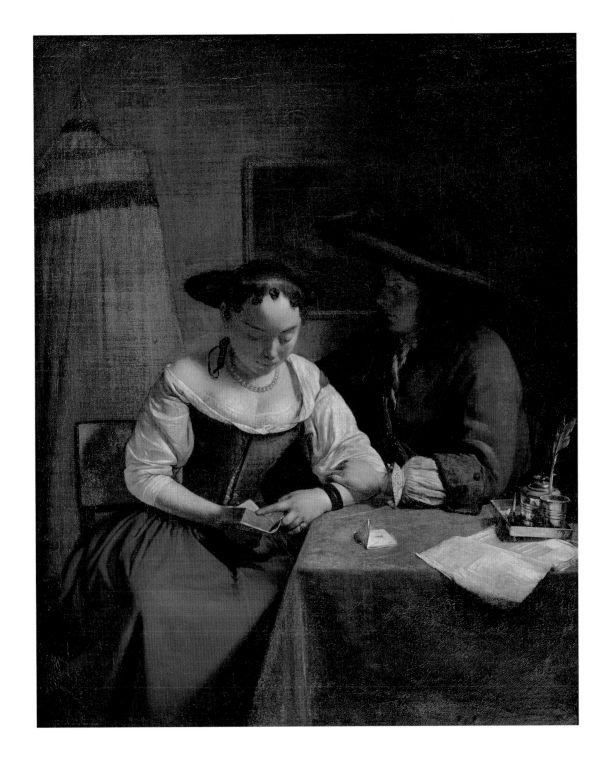

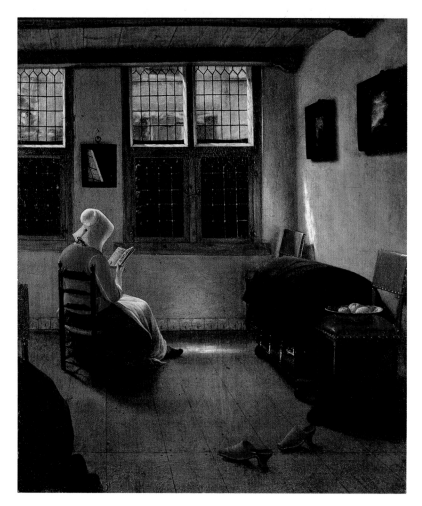

Pieter Janssens Elinga (1623–c. 1682)
Woman Reading, 1668–70
Alte Pinakothek, Munich

A GERMAN LADY'S MAID

Pieter Janssens Elinga

Engrossed in reading a best seller of the day, the lady's maid turns her back on the viewer of this painting. Instead of pursuing her duties, she is giving way to her love of reading. Experiencing their own turbulent emotions while reading gave women a new, delightful sense of self-awareness, which had never before played a part in the fulfillment of their prescribed role in society. ☙

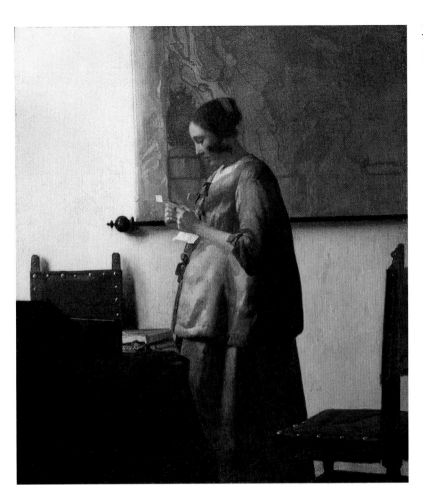

Johannes Vermeer (1632–1675)
Woman Reading a Letter, c. 1663–64
Rijksmuseum, Amsterdam

A DUTCH MOTHER-TO-BE

Johannes Vermeer

The woman, apparently pregnant, has turned toward the window and stands reading a letter that she has probably received from her husband. The map of southeast Holland on the wall in the background alludes to the absent writer. The woman's lips are parted, as though she were about to read the words of the letter aloud to herself—a sign of the intensity with which she takes in its content, but perhaps also of the effort it takes her to decipher the letter. As if in a protective covering, this reader shelters in an aura of intimacy that is radiated by the whole painting.

57

Abodes of Pleasure

It is certainly an exaggeration to claim that in the eighteenth century people did little else but enjoy and amuse themselves. In the age of Rococo and the Enlightenment, however, they certainly lived with the idea of pleasure in mind. Gone were the days when readers bent in concentration over heavy folios. Books now lay lightly in the hand, and the reading of poetry and novels became a new pastime offered by private life. Reading not only banished boredom; it also became an experience born out of individual freedom.

François Boucher (1703–1770)
Madame de Pompadour, 1756
Alte Pinakothek, Munich

François Boucher

The Marquise de Pompadour, the mistress of Louis XV who was despised for her extravagant lifestyle, actually came from a bourgeois background. From her twenty-fourth year onward, this illegitimate daughter of a Parisian merchant molded the taste of courtly France. When she was appointed a lady-in-waiting to the queen in 1756, she commissioned François Boucher, who would later be made Premier Peintre du Roi ("First Painter to the King"), to paint her portrait.

Nothing in this painting is there by chance. Even the scattered sheets of music, engravings, and writing utensils seek to imply casualness—after luxury and taste, the third indispensable attribute for the furnishings of a boudoir; no wonder that it appeared to contemporaries to be an "abode of sensuality." The central figure lounges in full court dress on a sofa in front of a mirror wall. In the mirror a richly decorated bookcase is reflected, its volumes bearing the coat of arms of their owner.

Everything here is intimate and yet everything is staged. Long before the birth of the mass media, this picture shows us a world of display of wishes and passions. It is still reading that rules in this realm of pleasure. The marquise has just looked up from her book, which she holds open with the thumb and index finger of her right hand. Her right lower arm and the fold in the book lie exactly on the diagonal that leads from top left of the painting to bottom right, where other books already lie scattered about. When this book too slips from her hand, the place on her lap will be free—perhaps for the little dog that sits at her feet, on the other diagonal in line with the marquise's head. But only until the king arrives. It is for him that she is waiting—this beautiful woman who always knew the right moment for everything. ✍

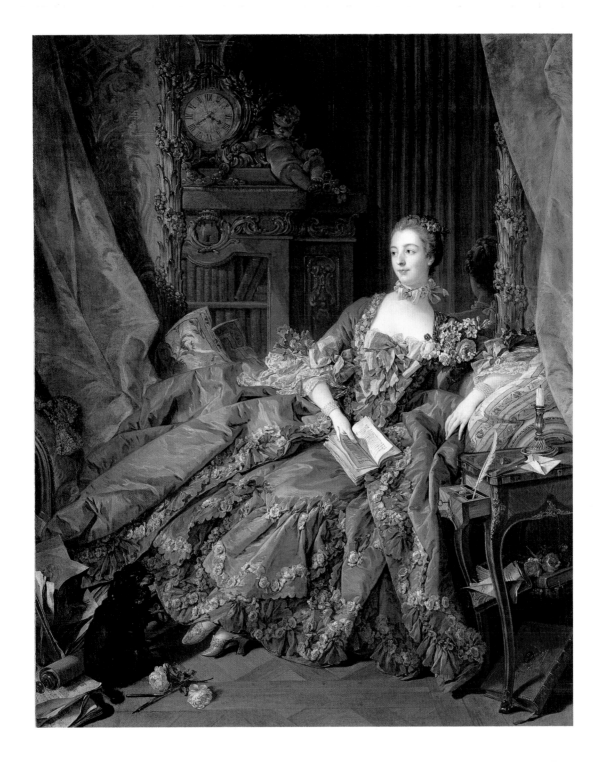

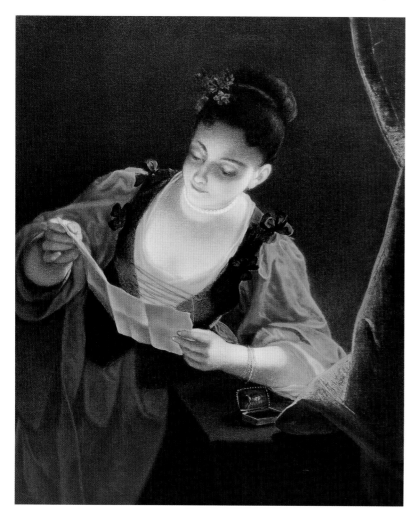

Jean Raoux (1677–1734)
The Letter, 1720
Louvre, Paris

AN EIGHTEENTH-CENTURY ROMANTIC

Jean Raoux

The French genre painters of the eighteenth century worked in the tradition of Dutch seventeenth-century painting, but they were more intent than their predecessors on holding fast a fleeting moment in time, depicting a precious instant. The painting becomes a complete snapshot: A gesture, a posture, an animated look capture the secret of femininity. The letter here is certainly a love letter (as suggested by the portrait of the man inside the lid of the open jewelry box), yet the picture is intended not to tell a story but to show us something—a moment of love. ☙

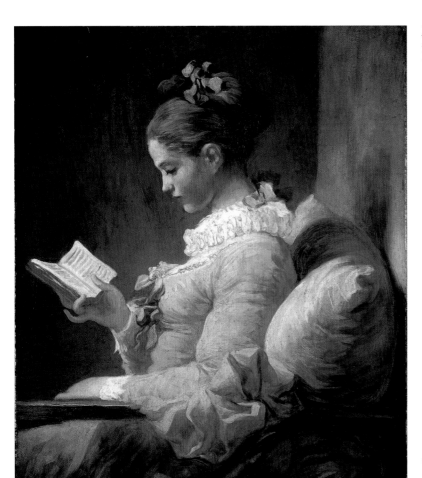

Jean-Honoré Fragonard (1732–1806)
A Young Girl Reading, c. 1776
National Gallery of Art, Washington, D.C.

A PROPER WOMAN OF MEANS

Jean-Honoré Fragonard

This young woman, dressed in the fashion of the day, holds the book she is reading in a seemly manner, as she would perhaps also hold a teacup—with only four fingers, the little finger very slightly splayed out. Reading is depicted as something light, almost floating; there is no longer any hint of laborious searching for the hidden meaning of the text. The painter succeeds in capturing two different views of the moment of reading: the vision attentively fixed on the lines on the page, and a free-floating gaze that loses itself in the feelings and reveries that arise from reading. ❧

Johann Ernst Heinsius (1731–1794)
Anna Amalia, Duchess of Saxe-Weimar, 1772–75
Stiftung Weimarer Klassik und
Kunstsammlungen/Museen

ANNA AMALIA

Johann Ernst Heinsius

When the German writer Johann Wolfgang von Goethe went to Weimar in early November 1775, the Duchy of Saxe-Weimar-Eisenach had been governed by a man for only two months: After the sudden death of Duke Ernst August Constantin, his consort, Anna Amalia, had become regent, and had managed the affairs of state for sixteen years on behalf of their young son, Carl August. In 1773 the regent's court painter, Johann Ernst Heinsius, painted her at the age of thirty-four. The open book in her left hand alludes to her as an aesthete, a patron of the arts and sciences, but above all of the culture of the book.

Anna Amalia transformed the small town of Weimar into a cultural center, so that it became, as the writer C. M. Wieland once remarked, an "institute for the promotion of good humor." She also made accessible the world-famous Library of the Public, later named for her. From 1761 to 1766 she had the "Grüne Schlösschen" (Little Green Castle), a former princely residence, rebuilt as a library. The Rococo library hall, with its historic stock of books, as well as paintings, maps, busts, and globes, represented the intellectual cosmos of Weimar Classicism. It remained almost unchanged for two hundred years, until September 2, 2004, when it was destroyed by a devastating fire. This painting had been hanging in the Duchess Anna Amalia Library, but was rescued from the blaze. ☙

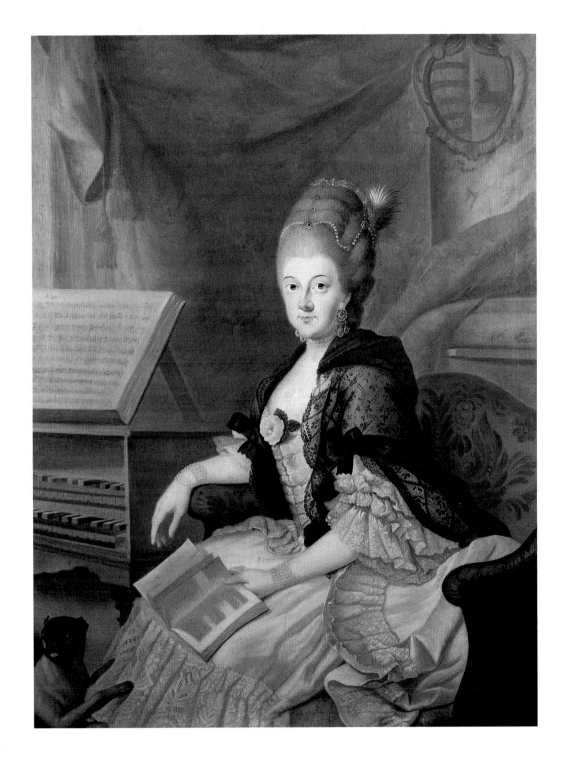

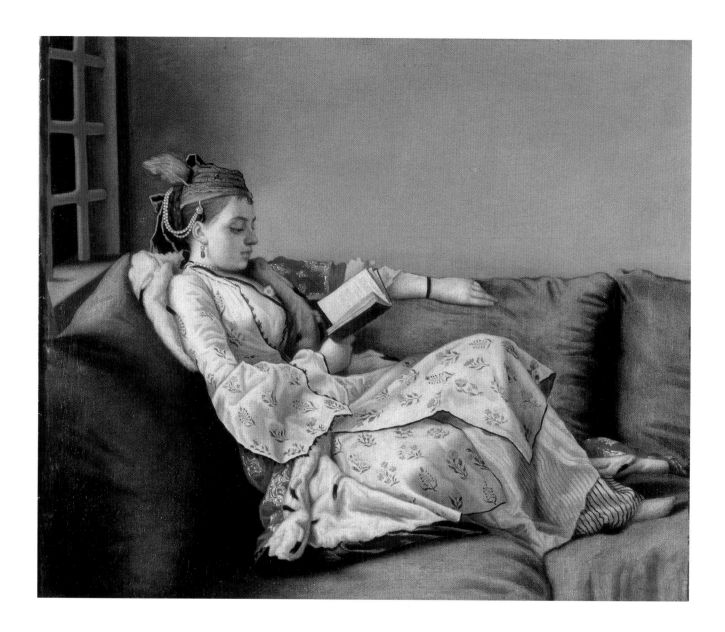

Jean-Etienne Liotard (1702–1789)
Marie Adelaïde of France, 1753
Uffizi, Florence

Jean-Etienne Liotard

The Geneva-born painter Jean-Etienne Liotard, an incessant traveler, was one of those eighteenth-century artists who journeyed from city to city and court to court, eager to preserve their freedom. Following his five-year stay in Constantinople (present-day Istanbul), Liotard adopted Turkish dress, a fur hat, and a beard down to his waist, which earned him the nickname "*peintre turc*" (Turkish painter) and had an extraordinarily positive effect on the sale of his paintings. He also liked to dress the ladies he portrayed, who included beautiful readers, in Turkish clothing. He abandoned his own costume after thirteen years, on the occasion of his marriage. The strength of Liotard's painting here lies in its delightful combination of Ottoman magic and female beauty. ✍

MARY MAGDALENE

Friedrich Heinrich Füger

In his autobiography, *Histoire de ma vie*, Giacomo Casanova names some of his lovers only by their initials. M. M., a nun, presents him with a gold tobacco-case in which her portrait appears twice. If the case is opened lengthwise, she is seen in her nun's habit. But if it is pressed against the edge, the case opens to show a separate portrait in which she is seen totally naked, lying in a pose "like Correggio's Mary Magdalene."

Casanova had probably seen Correggio's painting, which must have been made around 1520, in Dresden. It shows the biblical M. M. reading in a grove, with gentle light streaming through the trees. She lies on her front, her head supported by her right hand. The elbow of her right arm rests on a large-format book that is held by her left hand as it lies on the ground. The woman's shoulders and feet are bare.

This mixture of devoutness and sensuality seems to have been irresistible to the emotional individuals of the eighteenth century, or so we can infer from the many hymns of praise to and countless copies of the painting, which was lost during the Second World War. One of the copies was by Friedrich Heinrich Füger. The young painter was able to use it as an excellent introduction on his first visit to Vienna, the city in which he was to become director of the Academy. Thirty-five years later he painted his own version of Mary Magdalene reading. The most striking difference is that she is just looking up from her reading, and casts a wistful, dreamy glance in the direction of the observer. Although Füger's pleasant image is no match for Correggio's bewitching sensuality, his Mary Magdalene had an effect of its own: In 1809 Ludwig (later Ludwig I of Bavaria), acquired this work as his first contemporary painting, thus laying the foundations of the art collection in the Neue Pinakothek in Munich. And we know that Ludwig I, like Casanova, loved women. ✍

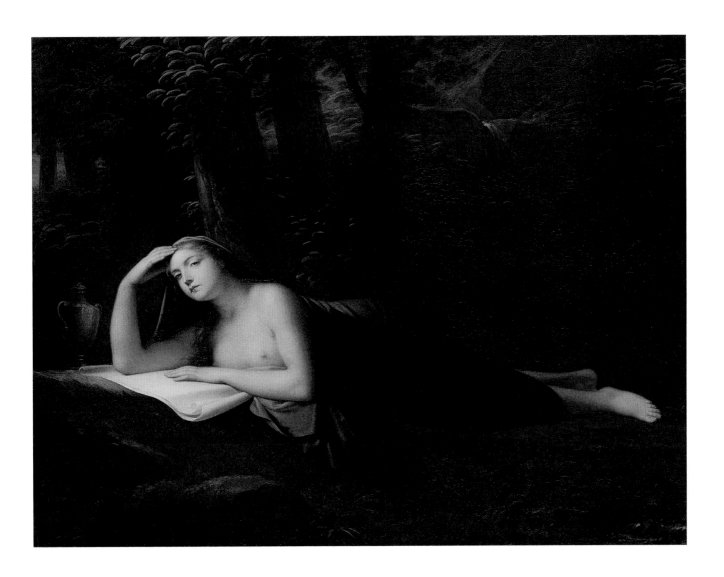

Hours of Delight

SENTIMENTAL READERS

The word *empfindsam*, which the critic and dramatist Gotthold Ephraim Lessing in 1768 proposed as a German equivalent to the English *sentimental*, quickly became a catchword among German-speakers to describe the new type of emotional life that bourgeois society was nurturing. A central role was given to reading in the practice of sentiment: Reading now meant identifying with the emotions of another as expressed on paper, and thereby exploring and expanding the horizons of one's own emotional potential.

Franz Eybl (1806–1880)
Girl Reading, 1850
Österreichische Galerie Belvedere, Vienna

A YOUNG VIENNESE WOMAN

Franz Eybl

This young woman is entirely engrossed in her reading. Her blouse has slipped unnoticed from her shoulder. Her right hand, which from time to time plays with her delicate necklace, is pressed against her breast. The book takes her breath away: Is it because the story is so exciting that she simply has to know how it goes on? Perhaps, but above all it's because her reading stimulates and enhances her potential for empathy. This inner excitement on the part of the reader is even reflected in the motion of the book; the pages that have been turned no longer lie flat together, and the slight gaps between them are open to the play of light.

This painting derives its charm from the portrayal of inner emotion coinciding with outer passivity. The artist, Franz Eybl, who in his entire life never left his native city of Vienna, had the best of entrées into society as a genre and portrait painter. He tended to portray idyllic scenes that are concerned with the everyday world of the Biedermeier period (c. 1815–48). Rather than actions, his works depict states of the inner emotional life, the representation of which became the great new challenge in painting in the nineteenth century. We see a young woman moved by what she is reading. Her thoughts seem to be as guileless as her face is charming and innocent. ☙

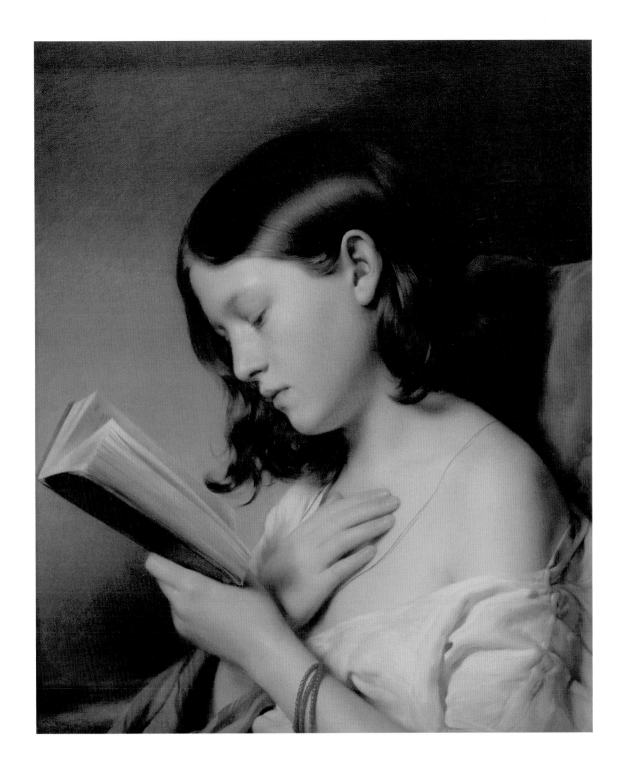

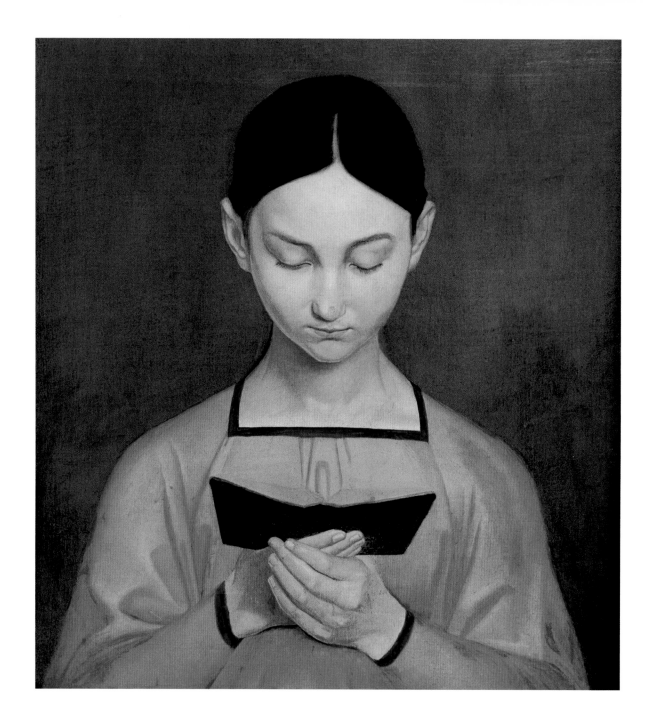

Gustav Adolph Hennig (1797–1869)
Girl Reading, 1828
Museum der Bildenden Künste, Leipzig

A STUDIOUS YOUNG GIRL

Gustav Adolph Hennig

This painting by Gustav Adolph Hennig, a neoclassical artist from Leipzig, derives its effect from its unpretentiousness, which at the same time gives it modernity. The monochrome background removes this reader from any social, cultural, or religious associations that might reveal anything about her life or motivation. The color of her hair is repeated in the black binding of the book that she holds close to her breast. Although the girl's humbly downcast eyes, and her attitude while reading, involuntarily suggest to us a book of prayer, the way it is painted implies that this is less a specific book than the embodiment of the "book" in the abstract. The crossed hands resting on the girl's bent knees express a pronounced self-consciousness, echoed by her slender facial features and thin lips pressed together. In spite of its strongly expressive color, the full gown, with its geometric neckline and merely suggested folds, is one of great simplicity and gives no hint of the female body concealed beneath it. All reference to the outside world, and all movement, have here been turned in on themselves.

This painting has appeared on the cover of the German edition of Alberto Manguel's *A History of Reading* (1996). In view of the richness of themes and motifs that the book weaves around its subject, this remote and ascetic figure on its cover might at first appear miscast. And yet the girl's very distance from the world and her inwardness exercise a certain seductive quality, as though the wish for retreat sought by sentimental readers were in good hands with her. ✍

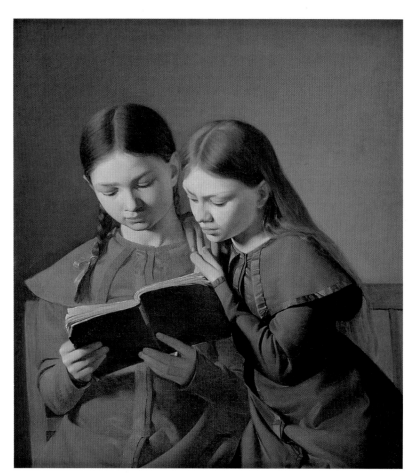

Carl Christian Constantin Hansen (1804–1880)
The Artist's Sisters, 1826
Nordiska Museet, Stockholm

TWO SISTERS

Carl Christian Constantin Hansen

The children and young people who inhabit many of the paintings of the Danish artist Constantin Hansen often gaze at the world with great wide-open eyes, as though amazed by something incomprehensible. The artist's two sisters seem gripped by a similar feeling in this painting, which shows them silently reading. The younger sister is holding the shoulder of the elder girl, as though to be closer to the book and at the same time to be lulled into a sense of security.

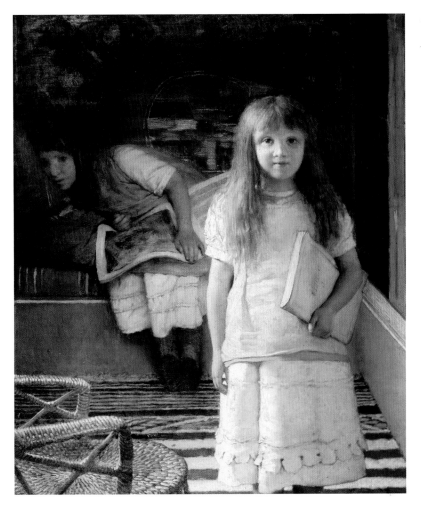

Sir Lawrence Alma-Tadema (1836–1912)
This is our Corner (Laurense and Anna Alma-Tadema), 1873
Rijksmuseum, Amsterdam

LAURENSE AND ANNA ALMA-TADEMA

Sir Lawrence Alma-Tadema

One shy, almost anxious, and dreamy, the other curious and self-assured—this is how Lawrence Alma-Tadema, the celebrated painter of history paintings in imitation of Classical models, portrayed the two daughters of his first marriage. This double portrait was a present from the artist to his second wife, and was perhaps intended to say, "Look, this is what we are like." It shows the sisters in their corner of their father's house, in which, however, nothing tells us anything about their presence except the girls themselves. Their actual, protected refuge within the world of adults is held by both in their hands: their books.

Anton Ebert (1845–1896)
Goodnight Story, 1883
Private collection

A MOTHER AND HER CHILDREN

Anton Ebert

The image of woman that has been handed down to us from the nineteenth century is that of a repository of emotion. The place where she sows and tends the delicate plants of sentiment, pity, and humanity is the family cell. The woman rarely leaves the inside of this cell in order to expose that emotion to the harsh reality that is the province of the man. Generally, she is active within the cell, as the protector and the provider of warmth to the family. At her breast infants develop an idea of life that offers them integrity and a sense of how that life might be later, after they leave the magic garden of childhood, if other things mattered beyond achievement and reality.

The artist Anton Ebert was highly regarded during his lifetime by his middle-class public. In his genre paintings he recorded in particular the idyllic moments of family life. In this picture it would have been unthinkable to introduce the father into the intimate circle of mother and children and place him in the bed with the others. However, this mother is not reading a bedtime story to her children, as the title of the painting incorrectly states. Rather, all three together are looking attentively and with shining eyes at an illustrated magazine, probably a foreign one; it shows them a picture of the world outside the protected family cell and presumably also beyond the sensible attitude that is embodied by the absent father.

Anselm Feuerbach (1829–1880)
Paolo and Francesca, 1864
Schack-Galerie, Munich

THE DIVINE COMEDY'S PAOLO AND FRANCESCA

Anselm Feuerbach

On his difficult journey through the Inferno of *The Divine Comedy*, Dante encounters the lovers Francesca da Rimini and Paolo Malatesta. The couple had committed adultery and had been caught in flagrante and killed by Francesca's unloved husband. Even in Hell, the mutual desire of the lovers has not faded, and Francesca tells Dante how their passion was first kindled: "One day / For our delight we read of Lancelot, / How him love thrall'd. Alone we were, and no / Suspicion near us. . . . When of that smile we read, / The wished smile, rapturously kiss'd / By one so deep in love, then he, who ne'er / From me shall separate, at once my lips / All trembling kiss'd. The book and writer both / Were love's purveyors. In its leaves that day / We read no more."

With the rediscovery of Dante in the eighteenth century, this scene became a popular subject for painting. Artists particularly liked to intensify the drama of the triangular story by depicting the lovers' kiss with the duped husband already lurking in the background with murderous intent. There is nothing of this in Anselm Feuerbach's painting. If we are to believe the reaction of contemporary viewers, it shows the two lovers silently engrossed as they read the courtly romance, and their sense of belonging together in harmony, peace, and contemplation.

Yet if we look a little more closely, we discover that Paolo is not reading at all, but, carefully positioning his arms and legs, is attempting an approach. Francesca has stopped reading and seems to be on the verge of turning toward him. Love's purveyor has done his work well, and pleasure triumphs over sentiment. ☙

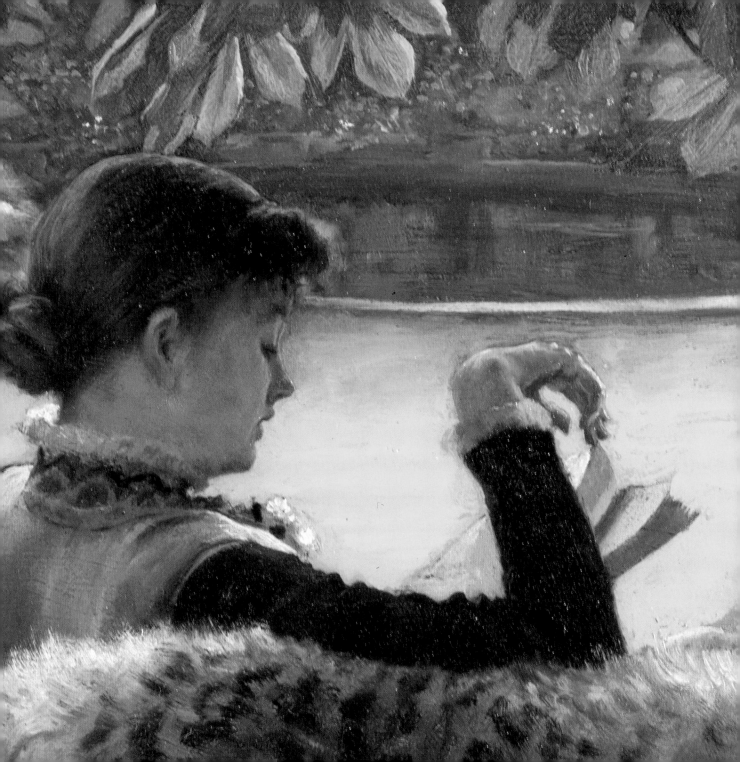

The Search for Oneself

Passionate readers, both male and female, very easily and all too happily yield to the temptation to equate reading with life. Gustave Flaubert even allows his poor Madame Bovary to destroy herself as a result of this flaw. She is the victim not only of false, kitsch books, but also of a self-deception that allows her to confuse books with oracles—as though the truth were a dish prepared by someone else, and we need only take it from the shelf before devouring it. Reading is an initiation into life and a stimulating force, but to confuse it with life itself is to take away its healing power and to turn a passion into a source of suffering.

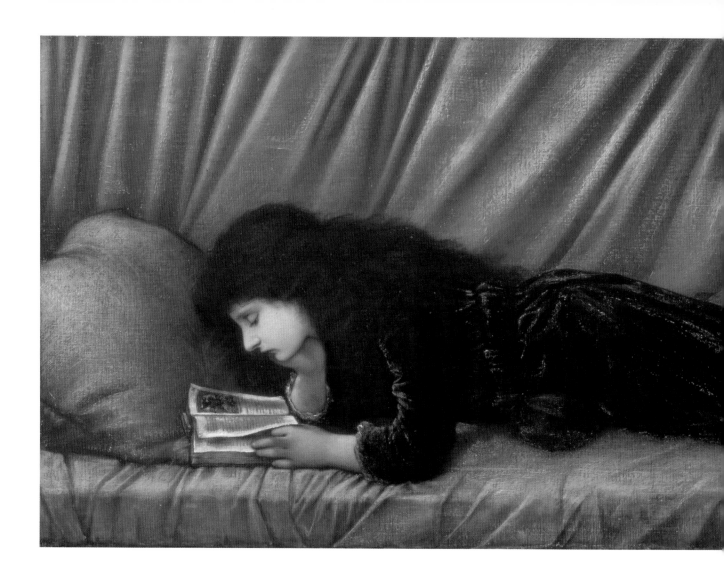

Sir Edward Burne-Jones (1833–1898)
Portrait of Katie Lewis, 1882–86
Private collection

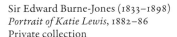

KATIE LEWIS

Sir Edward Burne-Jones

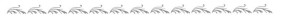

When the English painter and graphic artist Edward Burne-Jones began to paint this portrait of Katie Lewis lying on a sofa, absorbed in a book, she was four years old; by the time he completed it, she was eight. Katie was the youngest daughter of the famous barrister George Lewis, who represented such prominent artists as John Singer Sargent, Lawrence Alma-Tadema, and James McNeill Whistler, and the writer Oscar Wilde, and was a close friend of the painter. Burne-Jones, whose own children were by this time grown up, showered Katie with illustrated letters in which he told her amusing stories and indulged in childish jokes. His painting depicts the young girl as a passionate reader, comfortably sprawled on a sofa, with loose, somewhat untidy hair and sleeves rolled up. The story to which, at least for the moment, Katie is giving all her attention is not the usual reading matter considered suitable for little girls, but the romantic and bloody legend of St. George, who battles with the dragon and kills it. It was one of Burne-Jones's favorite stories and the subject of some of his paintings. And not only is Katie reading about knights; she even looks as if she comes from some bygone age. She lies on the sofa like a young medieval squire. 🖋

Ramón Casas i Carbó (1866–1932)
After the Ball, 1895
Museu de Montserrat, Catalonia

A YOUNG WOMAN AFTER A BALL

Ramón Casas i Carbó

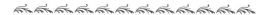

Influenced by Manet, Whistler, and Degas, the Catalan painter and graphic artist Ramón Casas not only created paintings that show him as a chronicler of his era, he also designed a number of advertising posters. Casas traveled a great deal, including in the United States and Cuba, and was co-founder of an artists' bar in Barcelona that became a gathering place for the avant garde.

The pose of the young lady who has sunk down on the sofa, exhausted after an enjoyable ball, holding a tattered booklet or novella that she has probably glanced at for distraction, was used again by Casas in a poster design for the periodical *Pèl & Ploma*. This magazine, illustrated by Casas and edited by the art critic Miguel Utrillo, was published between June 1899 and December 1903. In an advertising poster for the magazine, the young lady, wrapped in a gigantic pink shawl and still looking fresh and active, is reading a letter that she holds in her hands. In both versions of the subject, reading is depicted as a kind of snack between the great meals of life. One does not always have to wait around for life's most dramatic moments or exciting events; it is often in a brief interlude that more of the taste and weight of the world is experienced. In fact, these are the moments in which one becomes most aware of life. ✍

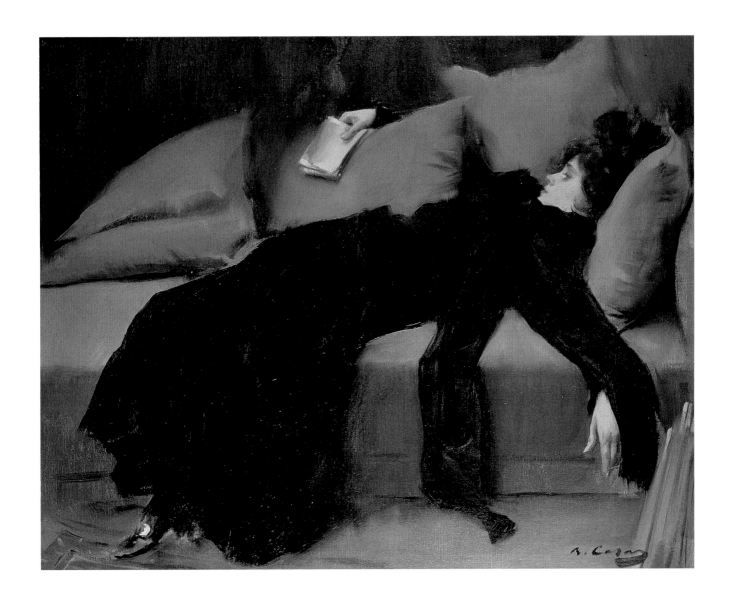

A WOMAN IN REPOSE

Jean-Jacques Henner

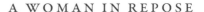

During a five-year stay at the Villa Medici in Rome, the Alsatian painter Jean-Jacques Henner perfected his manner, modeled on Correggio, of combining an ideal landscape (here only suggested) with a usually nude female figure to form an atmospheric idyll. His image of the reading woman unmistakably harks back to the Mary Magdalene type, as portrayed, for example, also by Correggio (see p. 68). However, this picture is not concerned with Christian iconography and its cryptic meaning. Rather, for Henner, painting has become a matter of series production. He caters to the taste of the time with continual variations on a popular theme, tailored to the emotions of a bourgeois public. ✎

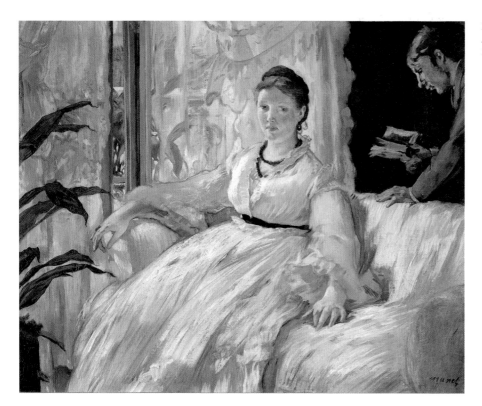

Edouard Manet (1832–1883)
Reading, 1865–73
Musée d'Orsay, Paris

SUZANNE MANET

Edouard Manet

La lecture, the original title of this painting, can mean either reading to oneself or reading aloud, an activity that gradually came to have less significance over the centuries. This portrait of Manet's wife, Suzanne, dressed all in white, was painted in 1865, but it was years before the artist opened up the homogeneous whitish background in one corner in order to add the figure of Suzanne's (and also often thought to be his own) son, Léon Leenhoff.

The voice of the son reading to his mother seems to reach her ear almost from offstage; in other respects, however, the painting shows no relationship at all between the two figures. ☙

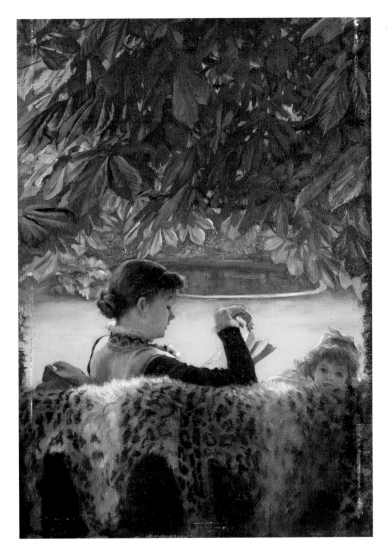

James Tissot (1836–1902)
Stillness, undated
Private collection

A FRENCH WOMAN AND HER CHILD

James Tissot

The custom of reading aloud to children has survived for a long time. Here, however, the painter has allowed several question marks to hover over this idyll of an intimate hour spent reading in the shade of a leafy overhanging tree. The skin of a predatory big cat in the foreground, on which the child is climbing, is echoed by the dark pool at the end of the lawn. It is as though the dimension of terror that exists in so many apparently benign children's stories has encroached on the scene. Stillness too can be sinister. Tissot made use of this motif several times. In another, similar painting, the child is captivated by the reading and not, as here, distracted by something we cannot see.

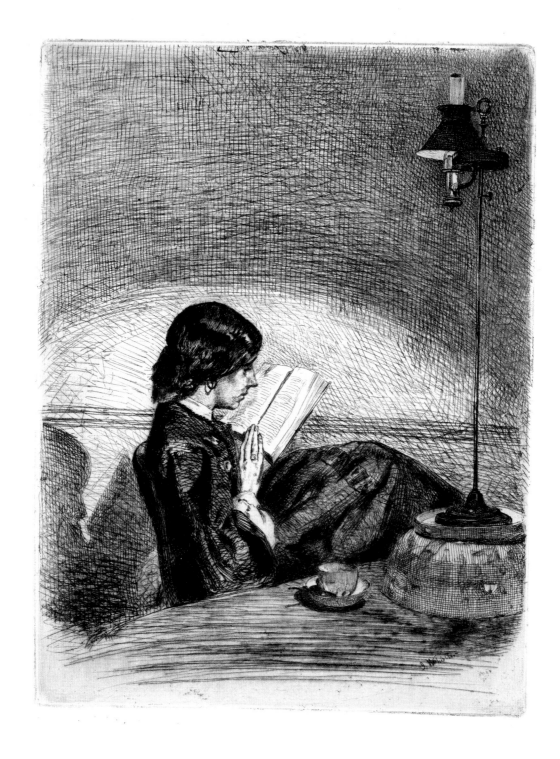

James Abbott McNeill Whistler (1834–1903)
Reading by Lamplight, 1858
Fine Art Society, London

DEBORAH HADEN

James Abbott McNeill Whistler

The painter and engraver Whistler, who was born in the United States, worked in London, and considered himself a Parisian, usually named his paintings after the dominant color mood: *Nocturne in Blue and Gold: Valparaíso Bay*; *Arrangement in Grey and Black No. 1: Portrait of the Artist's Mother*; or simply *Venice in Turquoise, Amsterdam in Topaz, Brittany in Opal*. Of the last-mentioned views, Marcel Proust wrote that they had put him into an indescribable state of nervous agitation, such as had never been achieved by the work of Manet or Degas. Whistler himself thought that the Impressionists were too realistic; he considered the Symbolists to be more modern.

Conversely, Whistler gave almost prosaic titles to his many drypoint engravings. *Reading by Lamplight* shows a young woman in profile, a cup of coffee or tea by her side, reading by the light of an oil lamp a book that she holds disturbingly close to her eyes. Since the light of the table lamp seems to be bright enough, one can only draw the conclusion that the reader is extremely shortsighted. Or perhaps she is simply concentrating hard, and wants as little distance as possible between herself and her book. Reader and book seem to become one: Nothing can interpose itself between them. This reader needs only a comfortable seat, light, and a gripping read to be happy for a time. 🖎

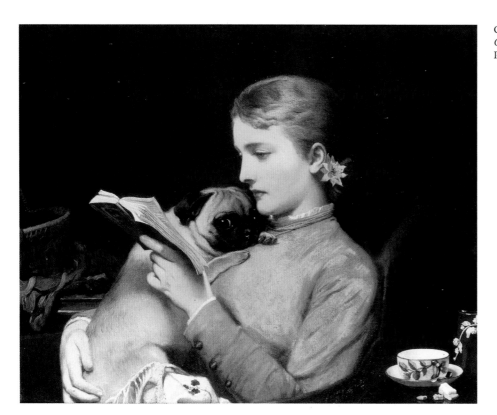

Charles Burton Barber (1845–1894)
Girl Reading with Pug, 1879
Private collection

A LADY AND HER DOG

Charles Burton Barber

Sports and animals—families of chickens and ducks, but especially dogs, including Queen Victoria's favorite dogs—were the preferred subjects of Charles Burton Barber. The chinoiserie teacup in this painting may be a reminder that the pug dog probably came to us from China. With the fashion for all things Chinese, the pug entered the houses of the middle classes and, both as a china figure and as a highly bred lapdog, soon became the darling of ladies, particularly those living alone. In this painting, however, he is the companion of a self-possessed, beautiful young woman.

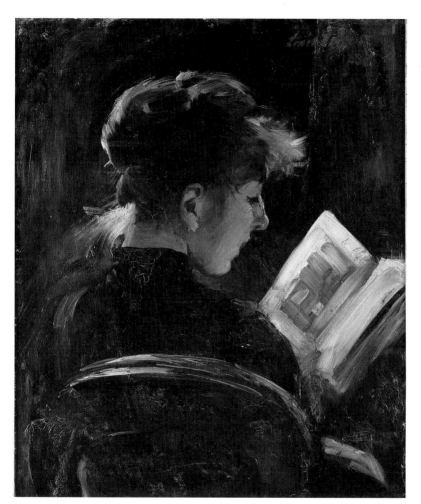

Lovis Corinth (1858–1925)
Girl Reading, 1888
Private collection

A YOUNG BOURGEOIS WOMAN

Lovis Corinth

~~~~~~~~~~~~~~

After several years' study in Paris—which, however, did not lead to a more intensive encounter with Impressionism—Corinth went to Berlin in the winter of 1887–88. There he adopted the pseudonym "Lovis," and painted his first self-portrait, almost in the manner of the Old Masters, and this beautiful image of a young woman reading. Its charm comes from its unusual viewpoint, a three-quarter view from behind, the so-called *profil perdu.* ≋

Théodore Roussel (1847–1926)
*The Reading Girl*, 1886–87
Tate, London

A MODEL AT REST

# Théodore Roussel

When the French painter Théodore Roussel exhibited his 27-square-foot (2.5-square-meter) painting *The Reading Girl* in his new home in London in 1887, the reviewer in the conservative *Spectator* magazine wrote indignantly of the "shameless arbitrariness" with which the painter had misappropriated a beautiful theme. It was the banality of the subject that particularly outraged the idealistic taste of the critic: The woman was no Venus, her nudity was therefore not heightened and justified by mythology, and she was not even reading a decent book. The reading material that the young woman is holding almost indifferently over her sexual parts (which, though invisible, are at the exact center of the image) is a magazine, with its gossip columns and strip cartoons. We are now living in the media age, and here we encounter one of its very first models—dispassionately relaxing, even already a little bored.

The indignation unleashed by Roussel's painting was based on its calculated provocativeness. As contemporaries were quick to observe, Roussel was alluding to Manet's painting Olympia, which more than twenty years earlier had had to be protected by two guards against blows from the walking sticks of infuriated visitors. It shows a prostitute awaiting the visit of a client. Not in terms of scandalousness but in banality, Roussel succeeded in surpassing the great Manet. For instead of suggesting a narrative element, he simply shows his nineteen-year-old model casually posing for him. Only the kimono, artfully draped over the back of the chair, introduces a touch of the exotic into the image. Soon the painter will resume his work, in order to show off at the next Salon with the life-size depiction of a nude that will, in as uncompromising a manner as *Olympia*, overturn the principle of art for art's sake. ✍

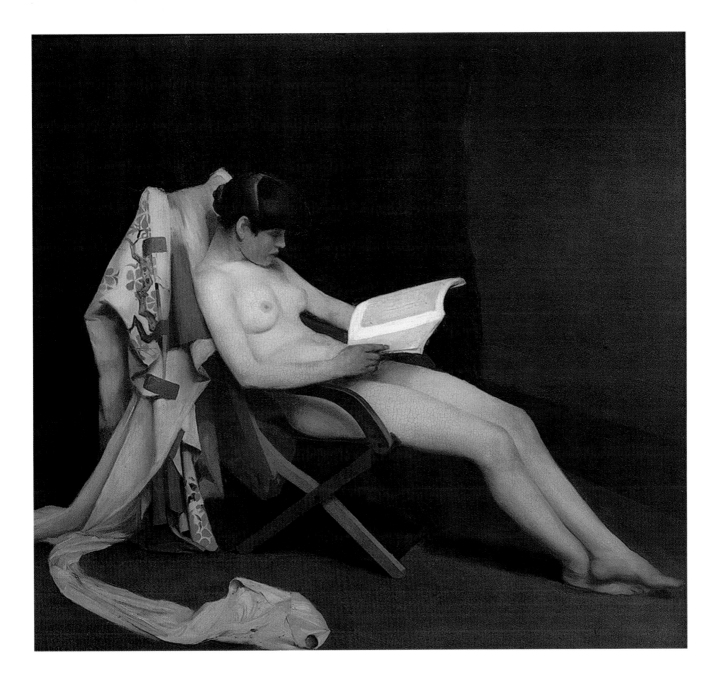

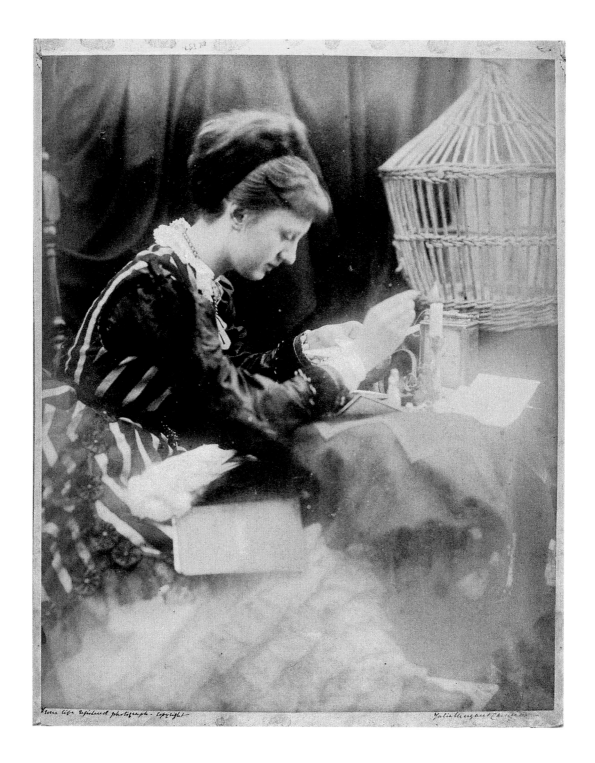

Julia Margaret Cameron

98

Julia Margaret Cameron (1815–1879)
*Our May*, 1870
Julia Margaret Cameron Trust,
Freshwater Bay, Isle of Wight

MAY PRINSEP

# Julia Margaret Cameron

Julia Margaret Cameron took up photography at the age of forty-nine, a mother of six grown children. Her daughter had given her a camera, with the words, "It may amuse you, Mother, to try to photograph during your solitude." Despite a lack of solitude, the hobby soon became great art. Cameron wrote in her memoirs that she had had a premonition that she would revolutionize photography, and even earn money doing so.

Cameron was of the firm opinion that photography, like painting, was a search for beauty. The portrait of her niece May Prinsep, shown here, is an excellent example. Cameron developed an artistic portrait photography in the then predominant style of the Pre-Raphaelites, oriented toward literature and strongly symbolistic. In her ambitious arrangements she attempted to portray and at the same time interpret biblical or mythological scenes. She also created a strongly expressive style of photography. The sculptural quality of her images was particularly important to her. What appeared to contemporaries to be technical inadequacy—Cameron's images always have one part in sharp focus and the rest softly blurred—in fact served her as an artistic means of expression with which she sought to attain a dramatic density and to represent emotions. ✎

Vincent van Gogh (1853–1890)
*L'Arlésienne (Madame Joseph-Michel Ginoux)*,
1888–89
Metropolitan Museum of Art, New York

MADAME JOSEPH-MICHEL GINOUX

# Vincent van Gogh

While living in Arles, in the south of France, Van Gogh frequented the Café de la Gare, owned by Joseph Ginoux, whose wife sat as the model for this portrait; as Van Gogh wrote to his brother, Theo, he "knocked it off" in three-quarters of an hour.

Like Chardin, Füger, and other artists, Van Gogh records not the process of reading itself, but its effect—when the gaze has freed itself from the lines of the book, and what has been read finds its echo and continuation in the thoughts of the reader. But unlike the subjects of Chardin, Füger, or, later, Vallotton, Van Gogh's reader turns away from the viewer toward an indefinable distance, while the posture of her head supported on her arm characterizes her as a melancholic. Like all mental activities, the act of reading resists naturalistic representation. The painter can only show us a person whose physical position and facial expression allow us to conclude that she is reading. There is a clear suggestion that the process of reading is satisfying in itself—as though the search for truth reaches its goal through reading alone. However, Van Gogh's Madame Ginoux appears to contradict this widespread view. The reading of books, this simple, older, wise woman seems to say to us, is only the threshold to intellectual life; it can lead us in, but it is not an end in itself.

Without their often astonishing color schemes, Van Gogh's portraits would not have that revelatory quality that continually surprises us. Here the almost screaming yellow of the background darkens the figure and at the same time allows it to seem garlanded with light. Van Gogh once remarked that he wanted to give men and women a "suggestion of the eternal": He was trying to reproduce "through the radiance and vibration of colors" what was once symbolized by the halo. ✎

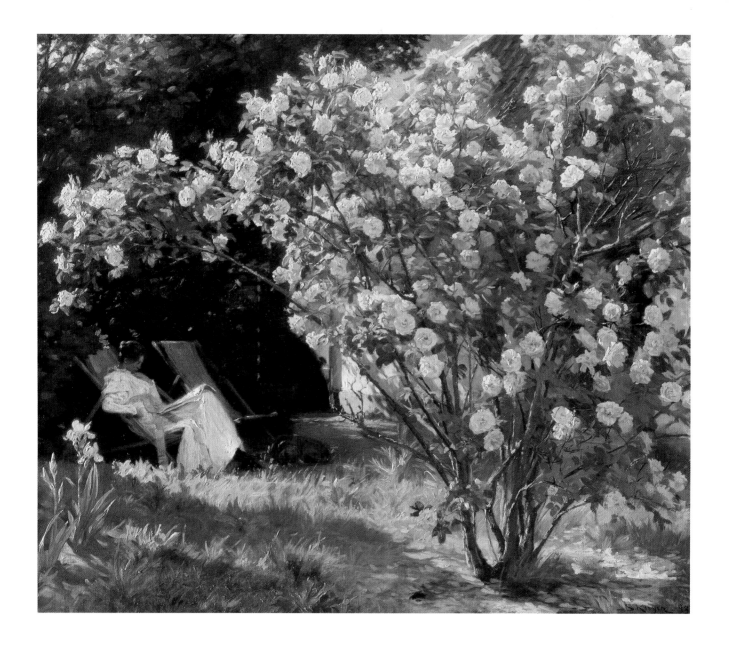

Peder Severin Krøyer (1851–1909)
*Rose Garden (The Artist's Wife
in the Garden at Skagen)*, 1893
Fine Art Society, London

MARIE KRØYER

# Peder Severin Krøyer

After stays in Paris, Spain, and Italy, the Norwegian-born Peder Severin Krøyer settled in the Danish artists' colony of Skagen. There, especially during the short Nordic summer, he painted a number of pictures in the garden of his house, several of them portraying his wife, Marie. He devoted a separate picture to the two deck chairs seen here; in both paintings, Marie lies in the left-hand chair, idly reading a newspaper, while the right-hand one remains empty, presumably waiting for the artist, who will return to his beloved wife's side when his work on the subject is done. We sense the influence of the Impressionists, who loved to paint out of doors, and portrayed their subjects in the open air. Reading in natural surroundings, in the summer sunshine, must have been a particular pleasure for Norwegians, who were used to long winters. ☙

Vittorio Matteo Corcos (1859–1933)
*Dreams*, 1896
Galleria Nazionale d'Arte Moderna, Rome

ELENA VECCHI

# Vittorio Matteo Corcos

Young, dreamy-looking women lost in thought, often in dubious surroundings, were the specialty of the Florentine painter Vittorio Matteo Corcos in the 1880s and 1890s. Corcos had studied in Paris for four years and had become familiar with the ambiguities of the Belle Epoque. A reminder of his stay is the pile of three yellow volumes from the famous series published by Garnier at the young woman's side.

The fallen leaves on the ground, as well as the discarded summer accessories, the straw hat and parasol, suggest the first theme of this painting: the transient nature of existence. Summer is followed by fall. But is this what the young woman is thinking about?

Among the wilting leaves there are also red petals: They have dropped off a rose that the pile of books has prevented from falling off the bench. The rose, especially the red rose, is a symbol of love; it too seems faded, past its best, dying. But the rose is also a symbol of innocence. In many parts of Europe, roses were traditionally thrown into a river by a bride on her wedding morning as a symbol of farewell to her girlhood. This may be a further theme of the painting. The departing summer has turned a young girl into a self-possessed woman. Perhaps her reading has also contributed to this change, so it could be that the rose has been serving as a bookmark. At any rate, the way in which the reader raises her head energetically and almost defiantly tells us one thing: She has no wish to return to her state of innocence. The title of the painting is misleading. This reader is no dreamer. ✦

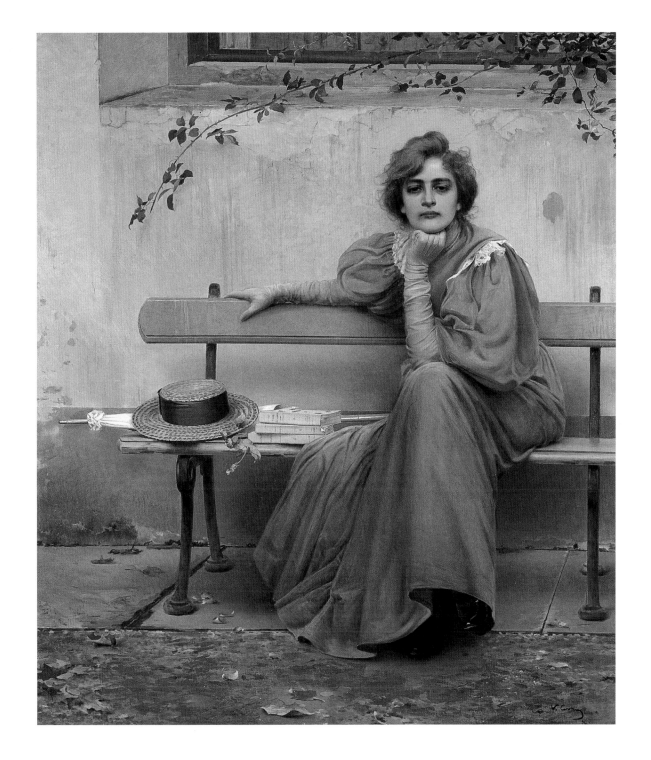

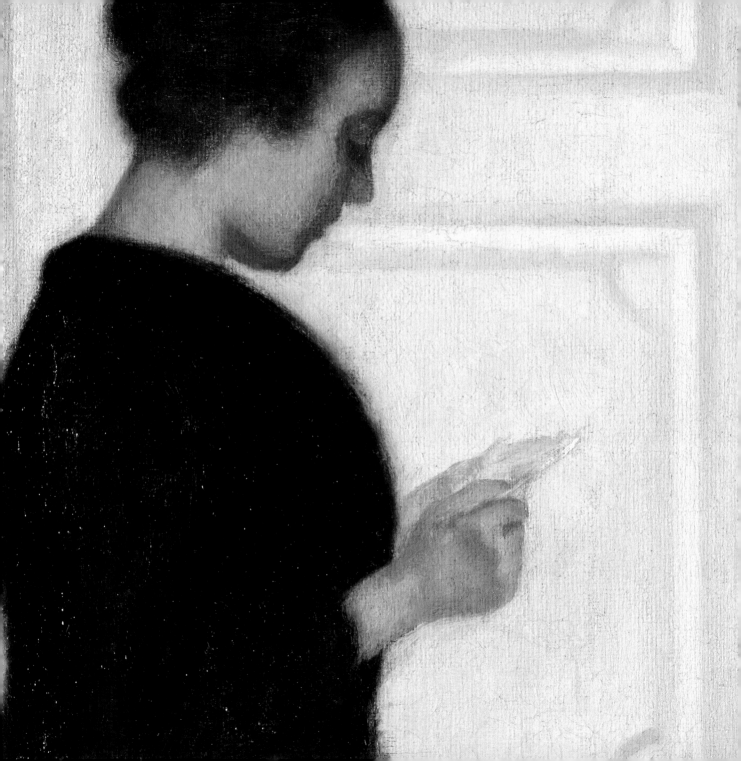

# Little Escapes

In the twentieth century the book became a mass-market product. Never before had books been so numerous and so inexpensive. It should have been a golden age of reading. However, the argument that books are becoming increasingly irrelevant compared to newspapers, movies, radio, television, and, finally, computers and the Internet, is true only when it comes to men. Women are reading not only more, but also in a different way. They are searching in books for the answers to the significant questions in life. Once a passion, reading now offers women the possibility of escape.

Jessie Marion King (1875–1949)
*The Magic Grammar*, c. 1900

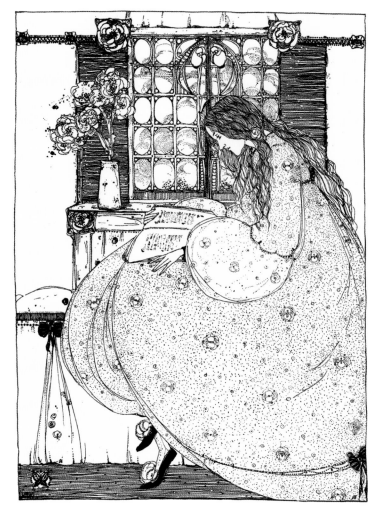

A TURN-OF-THE-CENTURY
WOMAN AND HER GRAMMAR

# Jessie Marion King

Art Nouveau emerged from commercial art and experienced its high point at the beginning of the twentieth century. Artists from all over Europe applied decoration to everyday objects as if with a magical power. The era of design was born. The "magic grammar" for which the Scottish illustrator and designer Jessie King created this image and which she places here in the hands of an innocent girl refers to the power and art of transformation. In this drawing, King links two of the famous roses designed by Charles Rennie Mackintosh to form a heart shape in the window; in the story, the hearts turn into girls, the girls into butterflies, and the butterflies into magic spells.

MARTHA VOGELER

# Heinrich Vogeler

The artists' colony of Worpswede, near Bremen in northeast Germany, was founded in the spirit of Art Nouveau. There the painter and book designer Heinrich Vogeler rebuilt a former farmhouse, the Barkenhoff, as an Art Nouveau building, and made it the focal point of the Worpswede art movement. Politicized by his experience of the First World War, he later founded a Communist school there; eventually he emigrated to Russia. Elements of his later objective realistic style can already be found, although without any ideological influence, in this drawing of his wife, Martha.

Carl Larsson (1853–1919)
*Karin Reading*, 1904
Zornsamlingarna, Mora

KARIN LARSSON

# Carl Larsson

The reformist Art Nouveau movement, which aimed to create a new aesthetic of living, included among its members the Swedish painter Carl Larsson. He became famous well beyond his homeland for the pictorial broadsheets in which he portrayed an idealized version of the daily life of his family of nine in a house in the country. For today's observer, the idyll of a life away from the bustle of the big city has an obvious appeal. But Larsson was pursuing a far greater goal with his pictorial journals: He wanted people to be freed from the boxes in which they had been locked up by the nineteenth century, and which they were now busy filling with imitations of earlier styles. Long before the avant-garde aspirations of the 1920s, Larsson promoted the idea of an inexpensive, welcoming house that was well suited to family life and in which an awareness of life, which needs light, air, movement, and openness, could flourish.

Larsson was a conservative, to the extent that he continued to believe that folk culture was the foundation of the Swedish nation. After the Second World War, however, the Swedes discovered that Larsson's ideal of unpretentious, family-oriented domesticity, with its bright, economically furnished rooms, was precisely suited to the needs and conditions of modern life. Ikea conquered the world market in home furnishings by following this model.

The painting shows Larsson's wife, Karin—who as a designer played a decisive role in shaping the new style of living—in the dining room of the couple's first house, "Lilla Hyttnäs." Electric light from a lamp, the shade of which is inspired by cactus flowers, provides pleasant light for reading. The profile of a woman seeking relaxation in reading after a day's work has its Art Nouveau counterpart in Karin's portrait on the glass in the background. ✍

AN AUSTRIAN SCHOOLTEACHER

# August Sander

Many ambitious photographic projects in the late 1920s and early 1930s set out to capture the "face of our time" with portraits of individuals who were meant to represent a particular occupation, an age group, or even a national characteristic. For his monumental comparative photography project, categorizing types of people according to their status in German society, August Sander returned to photographic portraits that had been created much earlier. All his images show a full-length figure in medium shot. And despite his classification of individuals according to occupation, a concept that was by then already outdated, Sander succeeded in producing impressive portraits of the people of his time. The expressive power of the portraits is all the greater the more they imply something beyond the anonymous social character that he had in mind when he took each photograph.

Books and texts, like the people who read them, are most likely to be found in literary and educational environments. Here the book again becomes a symbol, indicating a certain level of education in the reader in question. Sander himself was responsible for the famous saying: "In photography there are no unexplained shadows."

Vilhelm Hammershøi (1864–1916)
*Interior with Woman Reading
a Letter, Strandgade 30*, 1899
Private collection

IDA HAMMERSHØI

# Vilhelm Hammershøi

In 1898 the Danish painter Vilhelm Hammershøi, who was married to the sister of his fellow student Peter Ilsted (see p. 117), moved into a spacious apartment on the upper story of the seventeenth-century house at Strandgade 30, Copenhagen. Before moving in, the couple had the doors, windows, paneling, and moldings painted a uniform white, and the colored walls and ceilings painted gray. From then on, the sparsely furnished apartment served its occupants as laboratory and showroom for a school of interior painting as astonishing as it was enigmatic.

Interior with *Woman Reading a Letter* is one of the first paintings to have been created at the house. It is easily recognized as the mirror image of Vermeer's *Woman Reading a Letter* (see p. 57). Instead of turning her face to the window, Hammershøi's letter-reader is standing facing an open door that leads into the next room, and instead of standing in front of a map, which Vermeer uses to create a second reference to the outside world, the reader here is standing in profile in front of another door, this one closed. We know from a later painting that behind this door the familiar constellation is repeated: a room with two doors, one of which again is open.

All references that might embed the letter and its reader in the context of a narrative have been erased from Hammershøi's image. The room is not filled with objects, nor with people and their activities. Time does not hold its breath for an intimate moment; rather, it stands permanently still. Even the letter seems to come out of nowhere; it too in a sense is a door that refers only to itself. Any thought of escape from this suite of rooms, even on the imaginary wings of reading, is doomed to failure from the start. Hammershøi's interior shows us the paradox of a genre painting without genre. But where there is nothing more to be told, even readers become part of a rigid, lifeless set of accessories. ✍

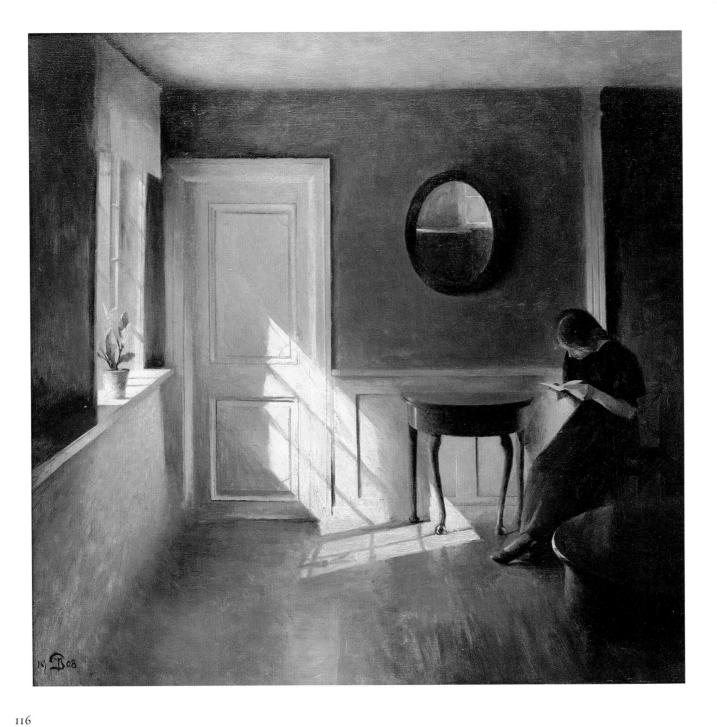

## A DANISH GIRL IN AFTERNOON LIGHT

# Peter Ilsted

Unlike his brother-in-law Vilhelm Hammershøi (see p. 114), who gave his interiors a disturbing, hallucinatory character, the Danish painter Peter Ilsted retreated into an atmosphere of intimacy. Warm brown color tones, subdued light, rounded forms that soften the angular aspects of the room, a young girl absorbed in her reading—all serve to give a nineteenth-century feeling to a twentieth-century apartment. This style of painting appeals to the longing for a cosy corner. Anyone who retreats into such a corner is expressing a wish to melt into the chosen spot, if only for a short time. In an era possessed by a mania for activity, this longing is all too understandable.

Albert Marquet (1875–1947)
*Standing Female Nude*, 1910
Private collection

ERNESTINE BAZIN

# Albert Marquet

The strengths of the French painter Albert Marquet, a friend of Matisse, certainly did not lie in his imagination. His work is dominated by views of harbors and urban and beach scenes that, nevertheless, unfold a poetry of their own in their minimalism and unpretentiousness. Marquet painted wherever he went. Usually, when traveling, he rented a room with a view of the harbor or the city and painted whatever met his eye, with authenticity if not with photographic precision.

A thematic exception in Marquet's work is formed by the nudes that he painted in his Paris studio between 1910 and 1912; they baffle us with their austerity and their apparent indifference. His women have nothing of the vibrant nakedness of a nude by Pierre Bonnard or the radiantly carefree mood of a Renoir; what distinguishes them is severity and a restrained assertiveness. Marquet's favorite model was his mistress, Yvonne, whose real name was Ernestine Bazin. He painted her either lying outstretched on a sofa or, as in this painting, standing upright and filling the image almost to its entire height. Her slender body is outlined with a thick black line.

As an artist, Marquet once said, he was in search of real life; it was not a question of a gesture or movement, whether beautiful or ugly, but of authenticity. For this reason, he shows his model not in a pose taken from some canon of beauty, but engrossed in reading a magazine, as though completely unaware of the presence of the painter (and of the viewer). 🐚

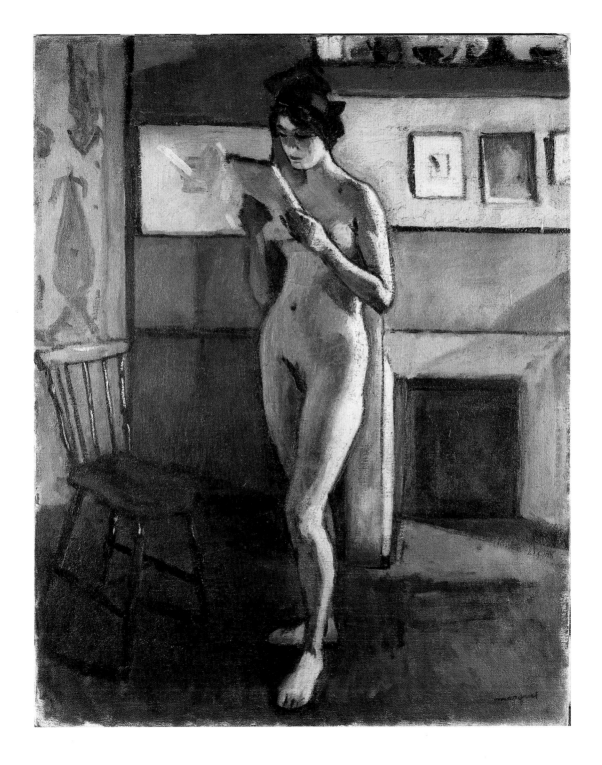

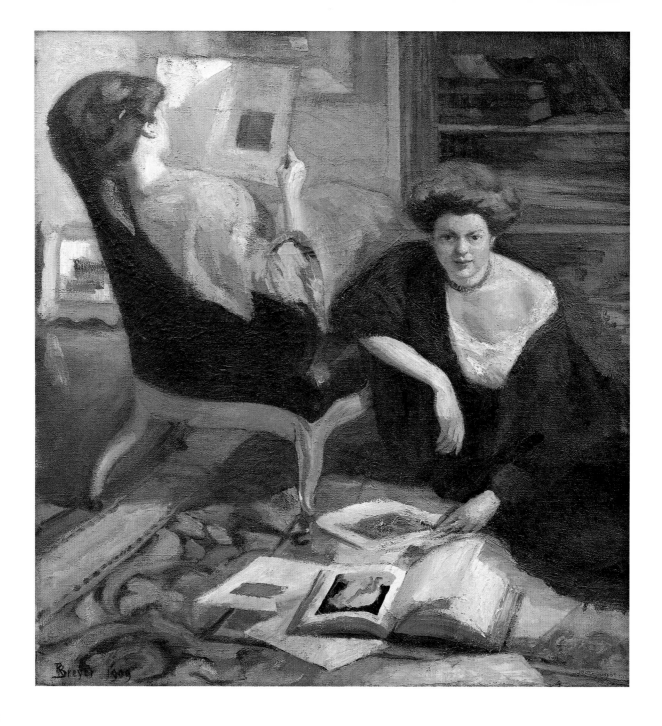

Robert Breyer (1866–1941)
*Women Reading*, 1909
Rolf Deyhle Collection, Stuttgart

TWO FASHIONABLE WOMEN

# Robert Breyer

Originally painted in a wide format, this painting was later substantially trimmed on the right-hand side and now focuses entirely on the two fashionably dressed and coiffured women. Although they are not directly communicating with each other, they are both engaged in the same activity. Their togetherness is also established by the fact that their two figures, next to one another, form a wavelike curved diagonal from the upper left to the lower right edge of the image.

While the woman in the blue dress sits sideways in her chair, almost completely turned away, letting her legs dangle in a relaxed manner and concentrating entirely on her reading, her friend has made herself comfortable on the floor. Facing the viewer, she is leafing through the books and magazines strewn on the carpet. The two typical reading postures depicted in paintings—absorption in what is being read, turned away from the viewer; or turned in the direction of the viewer while looking up from one's reading matter—are here combined harmoniously in one painting, divided between the two women. The image radiates equilibrium and balance, its mood characterized by confidentiality and security. ≈

A MOTHER IN THE LIBRARY

# Edouard Vuillard

Edouard Vuillard's early interiors, painted in the 1890s, give the impression that as an artist he was setting out to prove the famous formulation of his fellow student and colleague Maurice Denis that "a painting, before it becomes a war-horse, a naked woman, or an anecdote of any kind, is by its nature a flat surface covered with colors in a certain arrangement." Later, as in this work from the 1920s, Vuillard was to go back on this radical proposition that ignored three-dimensionality and perspective: The corners are no longer smoothed over, and the objects in the room are precisely depicted.

Vuillard's painting is still situated in an interior. However, the narrowness and oppression of the early works have given way to a certain spaciousness and airiness, and the prison-like sense of enclosure with no way out has been destroyed. In this evenly lit library it seems possible for a relationship to exist between the people present: The space is filled with the vibrations of human activity. The presence of the girl leaning against the door has also opened up the space with a view of the adjoining room, yet the intimacy of the situation has been preserved. Like many of his contemporaries, however, Vuillard suggests that the sinister and the terrifying may lurk in our emotions and in intimacy. ꞵ

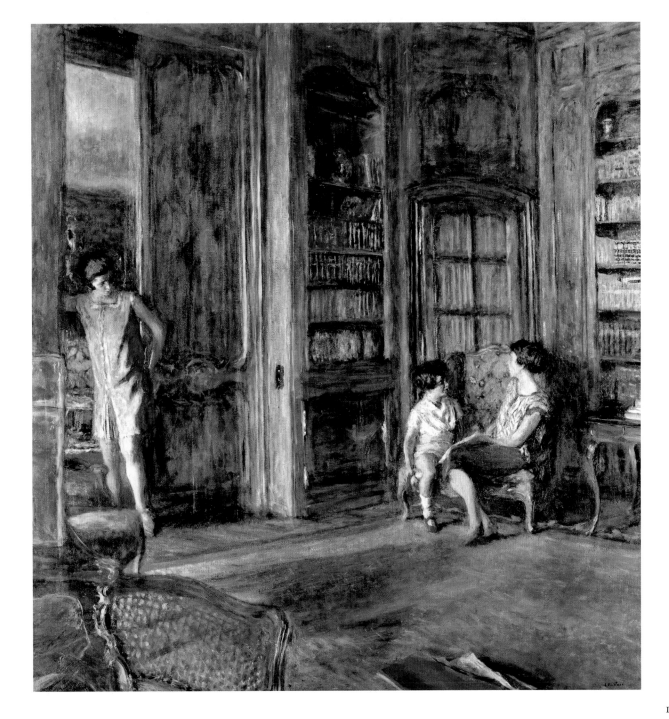

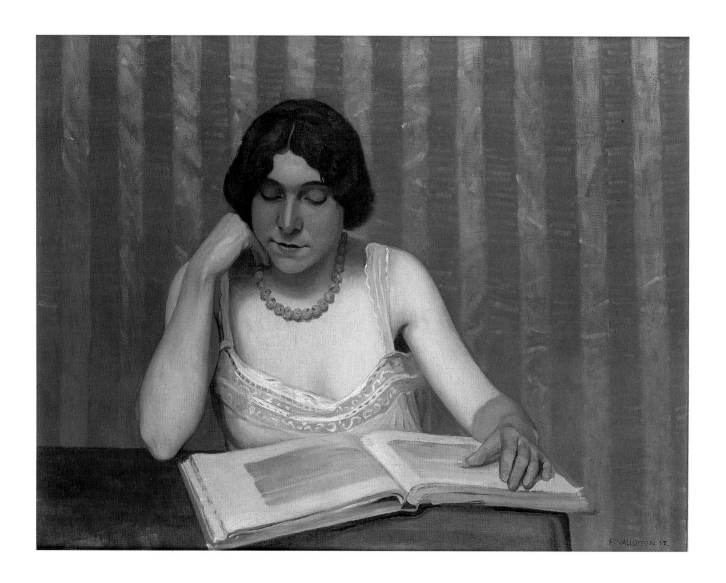

Félix Vallotton (1865–1925)
*Woman with Yellow Necklace Reading*, 1912
Private collection

A SWISS WOMAN AT HOME

# Félix Vallotton

If for Vuillard (see p. 122) the interior is both home and workplace, for his fellow painter from the Nabis group of artists, Swiss-born Félix Vallotton, it is an arena of human passions and sorrows. It is here that merciless battles between the sexes are waged, proclaiming themselves in the world of objects that furnish the room.

Yet all this is absent in *Woman with Yellow Necklace Reading*; the psychological backdrop has been abandoned and the feeling of oppression has given way to the composed contemplation of a book containing images of expansive landscapes. Even if the scene still has a slightly staged appearance, for a moment at least peace has returned and the harmonious triangle of gaze, arms, and book has triumphed over the tragicomedy of human relationships. Vallotton shows us a woman smiling mischievously, who seems to find peace within herself. ☙

A WOMAN IN BED

# Erich Heckel

Erich Heckel was a founding member of Die Brücke (The Bridge), an Expressionist group of artists initially comprising Ernst Ludwig Kirchner, Fritz Bleyl, and Karl Schmidt-Rottluff, as well as Heckel, all of them architectural students. Later they were joined by Max Pechstein, Emil Nolde, and Otto Müller. In 1910–11 Heckel painted *Studio Scene*. Four naked models, two of them partly hidden behind a screen, populate an artist's studio in which all the furniture and fittings, from the carpets to the net curtains, are designed by the Brücke artists. The models move around the space in an unconcerned and natural manner, making gestures without taking up poses. Their gaze is directed at an unrecognizable object with which one of them is playing. The painting gives the impression of having originated from a hastily drawn sketch. "All encounters in every-

day life," Kirchner wrote later, "were incorporated in the memory in this way. The studio became a homestead for the people who were being drawn. They learned from the artists and the artists from them. Directly and substantially, the images took in their life."

The same could be said about Heckel's *Woman Reading*. The woman has made herself comfortable on a sofa, half lying, half sitting, a blanket spread over her presumably naked body. This scene too could be taking place in the studio, as suggested by the picture in the background. The reading woman is pulling a face; her features remind us a little of African sculptures, which enjoyed great popularity among the Expressionists, particularly Nolde. This little painting, rapidly executed with wax crayon and opaque colors, is radiantly natural and unaffected. ✍

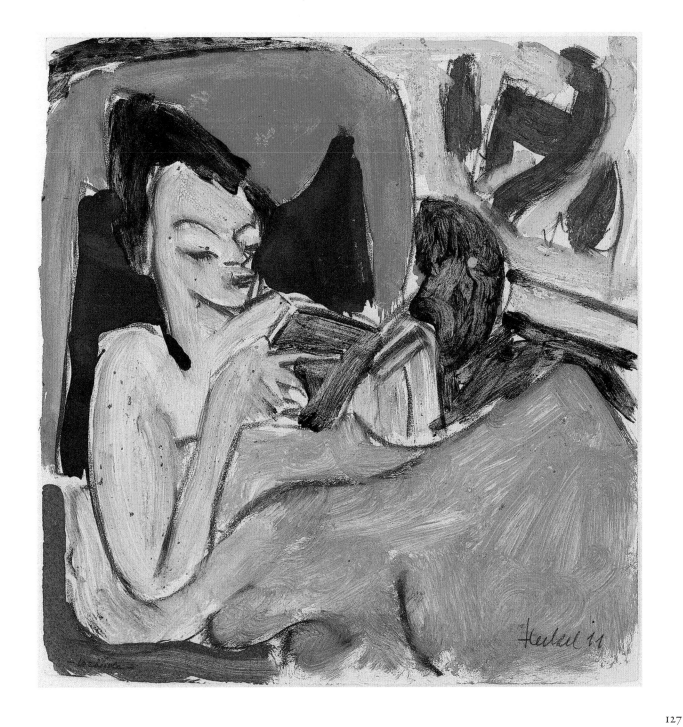

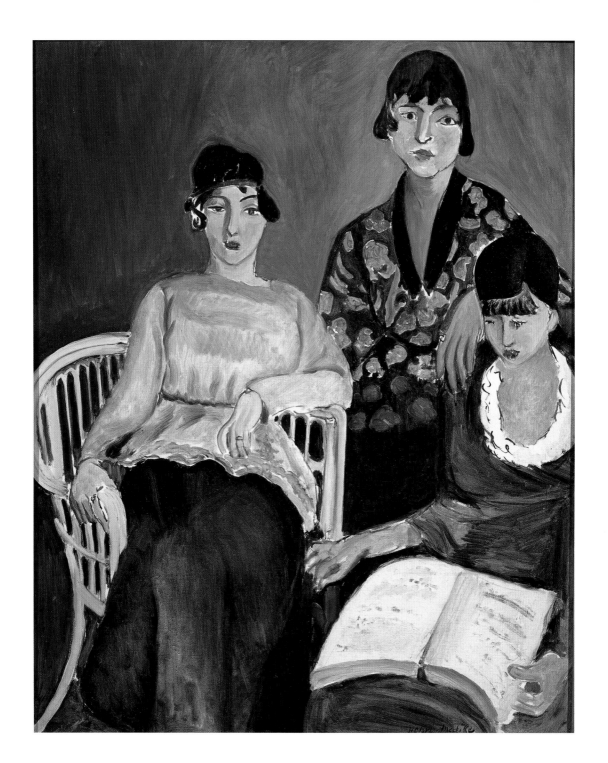

THREE SISTERS

# Henri Matisse

Unlike his great opposite number, Pablo Picasso, Henri Matisse was no witness to his age as far as his painting was concerned. His interiors are artistic paradises, filled with a promise of happiness that he maintained unerringly throughout his life. Only now and then do weak reflections of a social critique emerge from his paintings, as in *The Three Sisters* of 1917 (sometimes known as *Reading Aloud*). The three ladies—bored, blasé bluestockings—are clearly daughters of a well-to-do family. Having grown up in prosperity, they have cultivated an apathetic pleasure in life that could rapidly mutate into weariness at their protected existence.

Matisse painted other pictures with an identical theme during the same period. They include a triptych with each panel depicting three sisters in varying poses and moods, with various exotic coiffures and clothing, their expressions sometimes sensual, sometimes inscrutable. One model recurs in all the pictures in this series, a young Italian woman named Laurette (the middle one in this painting), whom Matisse met in 1916.

The triumvirate of women permits multiple, even mythological associations. One thinks of the Three Graces, and also the Muses, the patron goddesses of the arts, who were probably originally three sisters (later nine), and finally the Three Fates, who according to Classical mythology decided the fates of humans by first spinning the thread of their lives, then tightening it, and finally cutting it off. Matisse's painting is a play on these associations. And—who knows?— perhaps the three look so bored only because the book does not please them, and they do not have another on hand. 🖎

A FRENCH WOMAN AT LEISURE

# Suzanne Valadon

Marie-Clémentine Valadon, called Suzanne, came to painting after acting as a model for such artists as Renoir and Toulouse-Lautrec. A self-taught painter, she finally liberated the female nude from the false aura imposed on it by Salon painting and replaced the catalog of poses with a painted nudity that is as naturalistic as it is expressive. Valadon does not renounce the artistic approach to the female body, but frees it from conventional nude painting's double game of exaltation and degradation. Her paintings give the female body a presence and charisma of its own, without reference to a popular canon of beauty or the element of eroticism. In 1931 the artist, by then aged sixty-six, painted a portrait of herself as an older woman with naked breasts—an unprecedented innovation at this time.

The woman in this painting has thrown back the bedcover and is sitting on the sheet. Her discarded clothing hangs on the bedpost. In a relaxed mood, she leafs through a booklet. Like the woman in Edward Hopper's painting *Hotel Room* of nine years later (see p. 143), she seems to be in a hotel room, perhaps waiting for a lover. But unlike Hopper's existentially displaced traveler, she gives the impression of having found shelter here, even if only temporarily. The bedclothes, the colors of which pick up those of her skin, and the red carpet at her feet, frame her naked body and give it protection and security. ☙

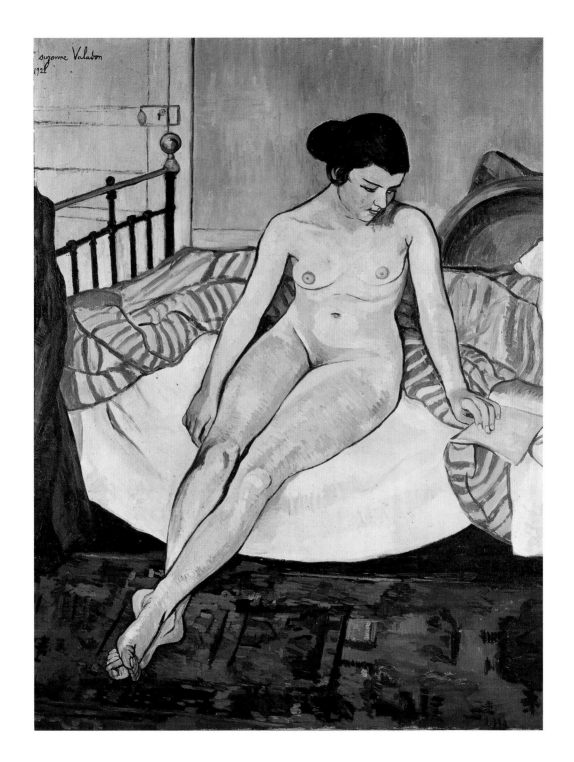

Gwen John (1876–1939)
*The Convalescent*, 1923–24
Fitzwilliam Museum,
University of Cambridge

THE CONVALESCENT

# Gwen John

Gwen John was one of the great British women painters of the twentieth century. The title *The Convalescent* was her own name for this painting; it is one of a series of ten works that she created between the late 1910s and the mid-1920s and which in obsessive repetition always show the same motif of the convalescent woman reading, sometimes a book rather than a letter. This version was probably painted by John for her close friend Isabel Bowser, who was in the hospital at the time.

We see here a young woman who appears very weak and tired, though at the same time determined. Her outward appearance is less important to John than her intense presence. The hesitant style in which the picture is painted suggests that the painter, like her subject, is in a state of exhaustion—as though an extraordinary effort is needed to save herself from the danger of failure.

Neurasthenia is a psychological disorder characterized by exhaustion, oversensitivity of the sensory organs, nervous irritability, and heightened self-consciousness. Many of John's contemporaries regarded it as a sensory condition that corresponded to the modern age and its art. Interestingly, the writer Marcel Proust took as his starting point the principle that in such cases reading could help and could take on the role otherwise played by the neurologist. The invalid needs an outside stimulus, but the intervention must be carried out within him- or herself. According to Proust, this is exactly the definition of reading—and only of reading. In this way it works as a remedy that gives us back our intellectual power and strength of will when we are going through a phase of exhaustion. Under the protection of reading we can be healed. ☙

Gabriele Münter (1877–1962)
*Woman Reading*, 1927
Gabriele Münter und Johannes Eichner
Stiftung, Munich

A SELF-POSSESSED WOMAN

# Gabriele Münter

Gabriele Münter's teacher and long-term partner, Wassily Kandinsky, wrote of the painter and graphic artist's "precise, discreet, delicate, and yet distinctive line." Around 1920, long after the period when she lived with Kandinsky in a house in Murnau, Bavaria, that can still be seen today, Münter made some pencil drawings of women sitting in an armchair. She called one of them *Versunken* ("deep in thought"). The drawing shows a woman sinking deep into her chair, with despair clearly written on her face. The expression of the model in *Woman in a Chair Looking Up*, on the other hand, is all arrogance. Only here in *Woman Reading* do we see a woman occupied with something other than herself. Her position, with legs wide apart and the upper body bent forward, radiates self-possession, energy, and concentration. This reader is living in the here and now. And like the artist who created her, she does not care much for convention. ⤚

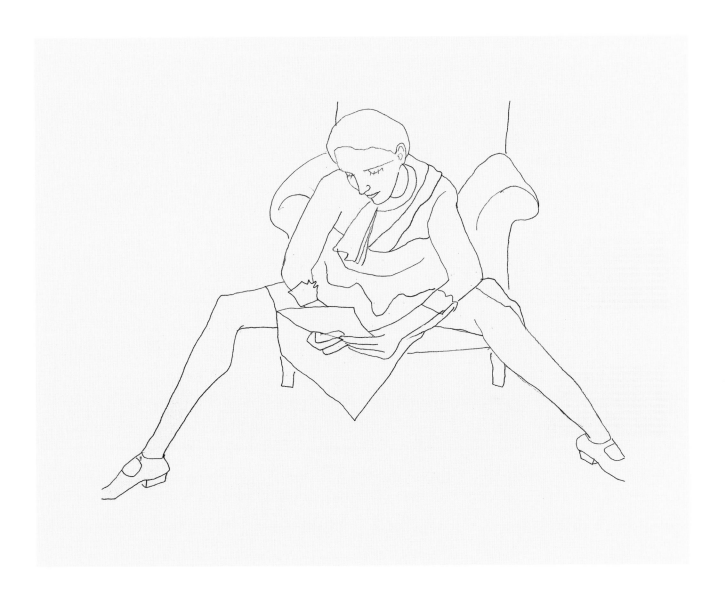

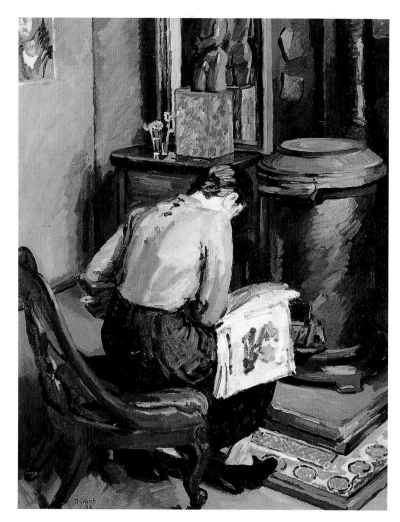

Duncan Grant (1885–1978)
*The Stove*, Fitzroy Square, 1936
Estate of Duncan Grant

ANGELICA BELL

# Duncan Grant

The two paintings on these pages take us into the world of the Bloomsbury Group (named for the London district in which many of the group lived). The best-known member of the group was probably the writer Virginia Woolf. Another central figure was the painter Duncan Grant, who was the father of Angelica, the daughter of Virginia's sister, Vanessa Bell. This picture shows Angelica sitting in *profil perdu* in front of a stove in Grant's studio, reading a magazine. When deeply absorbed in reading, one does not worry about posture, and so the reader shown here sits by the warm stove in a crooked position, fascinated by her magazine. ❦

Vanessa Bell (1879–1961)
*Amaryllis and Henrietta*, 1952
Estate of Vanessa Bell

AMARYLLIS AND
HENRIETTA GARNETT

# Vanessa Bell

Vanessa Bell was a painter, designer, and interior decorator. In 1914, while still married to Clive Bell and after a love affair with Roger Fry, she moved in with Duncan Grant. In 1942 their daughter Angelica, against her mother's wishes, married David Garnett, a former lover of her father's. Here Bell has painted two of the four daughters of this marriage in intimate togetherness, reading on a sofa. They are said to have been paid sixpence an hour for sitting as models for their grandmother. ❧

Cagnaccio di San Pietro, pseudonym of
Natalino Bentivoglio Scarpa (1897–1946)
*Portrait of Signora Vighi*, 1930–36
Private collection

SIGNORA VIGHI

# Cagnaccio di San Pietro

Cagnaccio ("Bad Dog") di San Pietro was the pseudonym of Natalino Bentivoglio Scarpa. After breaking with Futurism in the early 1920s, he turned to the more representative art of the Neue Sachlichkeit (New Objectivity) movement. The influences of Otto Dix and in particular Christian Schad, whom he probably also knew personally, are unmistakable.

This cool and distanced portrait of the wife of the Venetian lawyer Vighi shows her imprisoned in her bourgeois salon. The porcelain animals on the small table proclaim a love of childish pleasures; presumably they refer to an amorous relationship between the little dog (the artist known as "Bad Dog") and the lawyer's wife, whose red dress is echoed in the color of the cock's comb and wattle. The figure of the cock may refer to the husband; the term *becco* (beak) in Italian also means "cuckold."

The childish quality of the porcelain figures is repeated in the woman's face, in which a look of surprise, such as is often found in children's paintings, is mingled with deep melancholy. The picture speaks of the painful experience of having outlived oneself, to have been the child of a time that has long since passed, without the possibility of regeneration. Even reading seems here to have lost its restorative power.

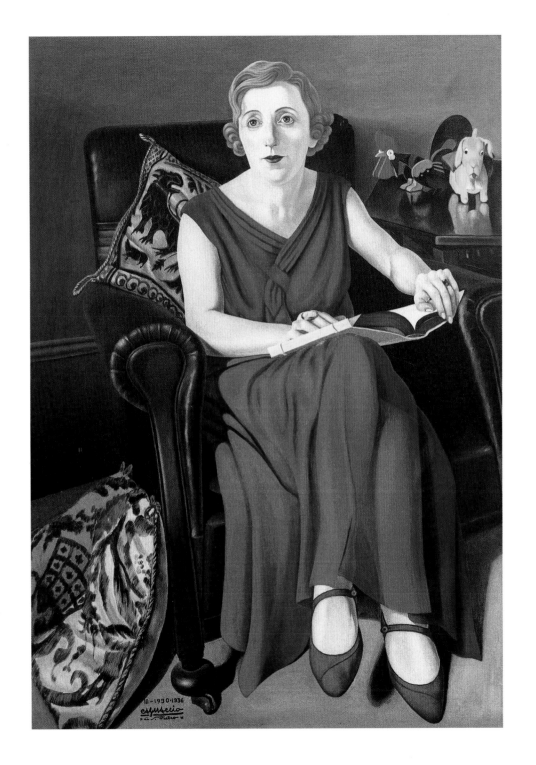

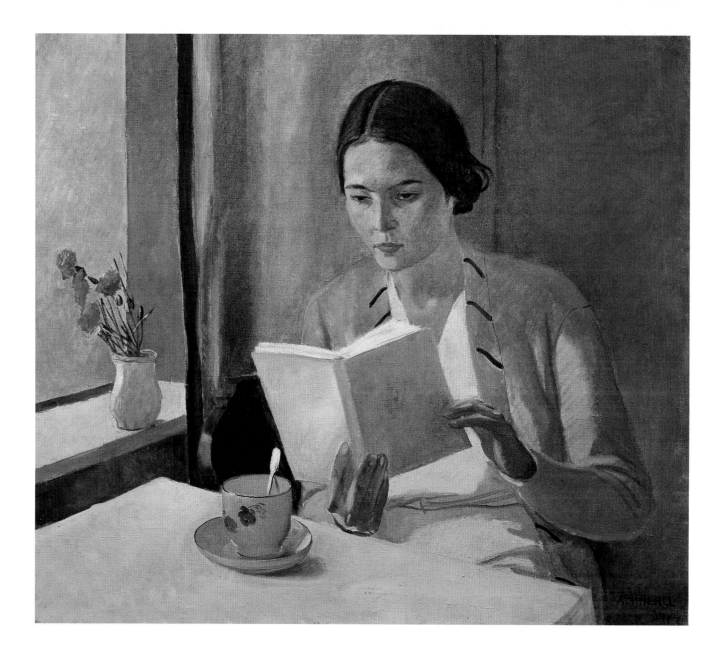

Aleksandr Aleksandrovich Deineka (1899–1969)
*Young Woman with Book*, 1934
Russian State Museum, St. Petersburg

A YOUNG LADY IN A CAFÉ

# Aleksandr Aleksandrovich Deineka

From the outset, Aleksandr Deineka's art was directly connected with the social upheavals in Russia after the October Revolution of 1917. Deineka saw himself not only as a chronicler of, but also a pathfinder for the Communist society that was emerging. He sought new styles of work beyond the aesthetic clichés of the nineteenth century, finding them in Futurism, Constructivism, and photomontage. His illustrations, posters, murals, and monumental works were intended to have a direct effect, to the point of being propaganda. He favored such themes as industrial labor, revolution, physical education, and sports.

Aside from the monumental and the inflammatory, however, there is also an intimate, poetic dimension to Deineka's work, for which in fact he returned to late nineteenth-century influences after being stimulated on his journeys abroad by the "bourgeois" art movements of the day. In the early 1930s he painted a series of portraits of women. They show young women who undoubtedly have both feet planted in the present, but who do not work in the narrow sense of the word: They bathe, enjoy the pleasures of motherhood, or read, like the pretty woman in this picture who cannot be distracted from the object of her fierce concentration. It would be going too far to describe these women as ambassadors of the brave new world, but they are evidence of women's progress toward a new independence and self-determination. ✍

A TRAVELER

# Edward Hopper

In 1931 the American Edward Hopper painted *Hotel Room*, an almost square painting, comparatively large for him. A woman in her underwear sits on a hotel bed; she has slipped off her shoes and carefully placed her dress over the arm of a green chair behind the bed; she has not yet unpacked her bag and suitcase. The deeply dark, almost completely black space below the yellow roller blind tells us that it is night. The woman, whose features are in shadow, is reading not a letter but a leaflet, presumably a timetable. She seems indecisive, almost baffled, and defenseless. Over the rigid scene lies the melancholy of railroad stations and anonymous hotel rooms, of being on a journey without arriving, of the arrival that is merely a short stopover before a further departure. Hopper's timetable-reader is as deep in thought as the letter-readers of seventeenth-century Dutch painting. But here this absorption has no object; the reader is existentially homeless, expressing an unease with the modern world.

Hopper's readers are not dangerous, but endangered—less by an unfettered power of imagination than by the modern popular illness, depression. A painting made seven years later shows a similar woman in a train compartment: She too is reading, a leaflet in a larger format. According to these images, an incurable melancholy now lingers over men and women who read, as though the cheerful chaos of reading mania has in the end become as indifferent as the expressions of Hopper's women readers and the printed matter that occupies them without any real engagement.

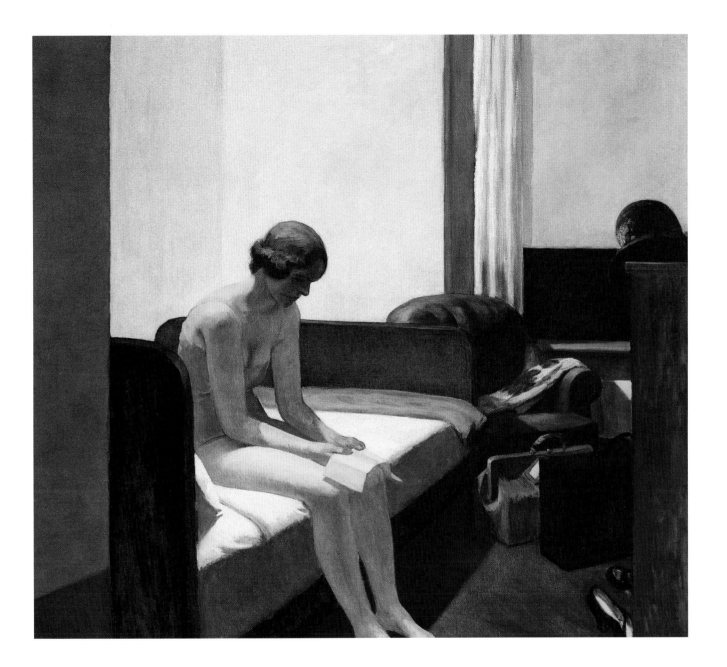

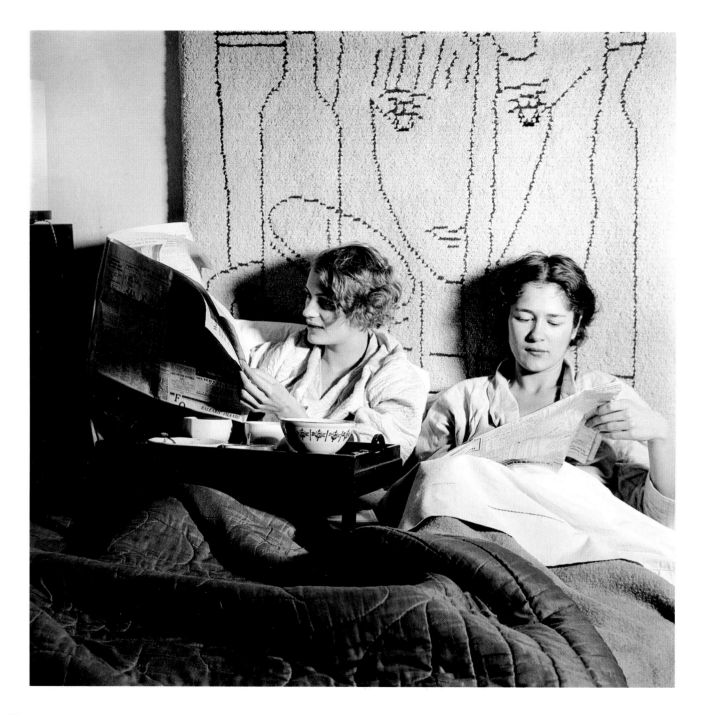

Theodore Miller (1872–1971)
*Lee Miller and Tanja Ramm*
Lee Miller Archives

LEE MILLER AND TANJA RAMM

# Theodore Miller

Lee Miller (1907–1977), born in the small industrial town of Poughkeepsie in New York State, moved to Paris in 1929, where she became the model, student, and lover of Man Ray. It was not long before she had taken up a camera herself, had her own studio, and was taking photographs in a Surrealist style; she later specialized in fashion and portrait photography. It was for her photographs from the last two years of the Second World War and of the concentration camps after liberation, however, that Miller became internationally famous. In 1944 and 1945 she followed the American army as a war reporter through Cologne, Frankfurt am Main, and Heidelberg to Torgau; in April 1945 she reached Buchenwald. She then traveled via Leipzig, Nuremberg, and Dachau to Munich, where she installed herself in Hitler's private apartment on the day he committed suicide in his Berlin bunker (a photo taken by fellow photographer David Scherman shows her in Hitler's bathtub). After Buchenwald and Dachau, where Miller photographed the murdered bodies heaped upon each other as well as the exhausted survivors, she is said never to have been the same again.

This photograph dates from carefree days, when all still seemed right with the world. It shows Miller in her Paris studio with her best friend, Tanja Ramm from Poughkeepsie, having breakfast in bed and reading the newspaper. The wall-hanging by Jean Cocteau in the background lends a touch of melancholy to the generally cheerful scene. This is how one wants life to be, and how it can never be again. The photograph was probably taken by Theodore Miller, Lee's father, who was a passionate amateur photographer. 🖎

Eve Arnold (born 1913)
*Marilyn Reading Ulysses*, 1952
Eve Arnold/Magnum/Focus Agency

MARILYN MONROE

# Eve Arnold

The question "Did she or didn't she?" is almost unavoidable. Did Marilyn Monroe, the blonde sex symbol of the twentieth century, read James Joyce's *Ulysses*, a twentieth-century icon of highbrow culture and the book many consider to be the greatest modern novel—or was she only pretending? For, as other images from the same photographic session make clear, *Ulysses* is the book that Marilyn is seen reading here.

A professor of literature, Richard Brown, wanted to find out. Thirty years after the photo session, he wrote to the photographer, who ought to know the answer. Eve Arnold replied that Marilyn was already reading *Ulysses* when they met. Marilyn had said that she liked the style of the book; she would read it aloud in order to understand it better,

but it was hard work. Before the photo shoot, Marilyn was reading *Ulysses* while Arnold loaded her film. And this was how she was photographed. We need not pursue Professor Brown's fantasy that Marilyn continued her reading of *Ulysses*, registered at a college, and abandoned her life as a movie star so as to further her research into Joyce, and that as a retired college lecturer she looked back on the exciting days of her youth.

But we can follow Professor Brown's recommendation to read *Ulysses* as Marilyn did: not in sequence, from start to finish, but episodically, by opening the book at different points and reading in short bursts. We could perhaps call this disorganized way of reading the Marilyn method. At any rate, Professor Brown recommends it to his students. ✎

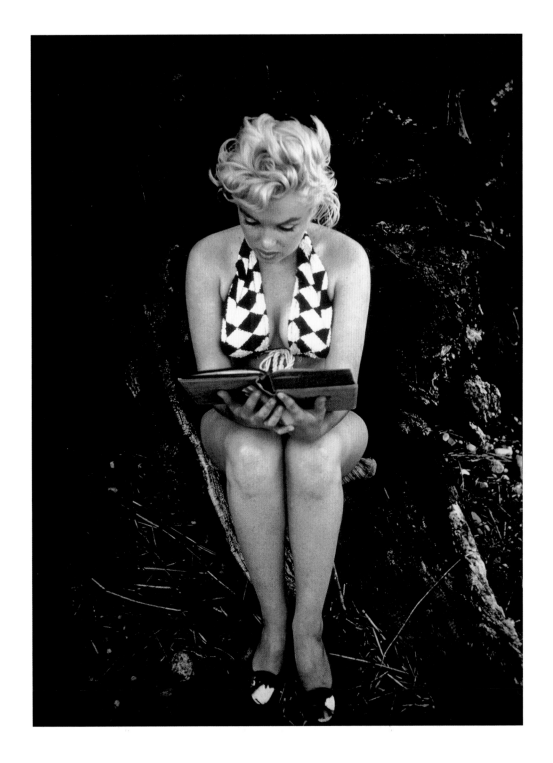

# Picture Credits

Front cover: V. M. Corcos, *Dreams*, 1896, Galleria Nazionale d'Arte Moderna, Rome | AKG-Images/Pirozzi

Back cover: T. Miller, *Lee Miller and Tanja Ramm* | Lee Miller Archives; tapestry: Jean Cocteau | VG Bild-Kunst, Bonn 2015, kindly granted permission by Pierre Bergé, president of the Jean Cocteau Committee

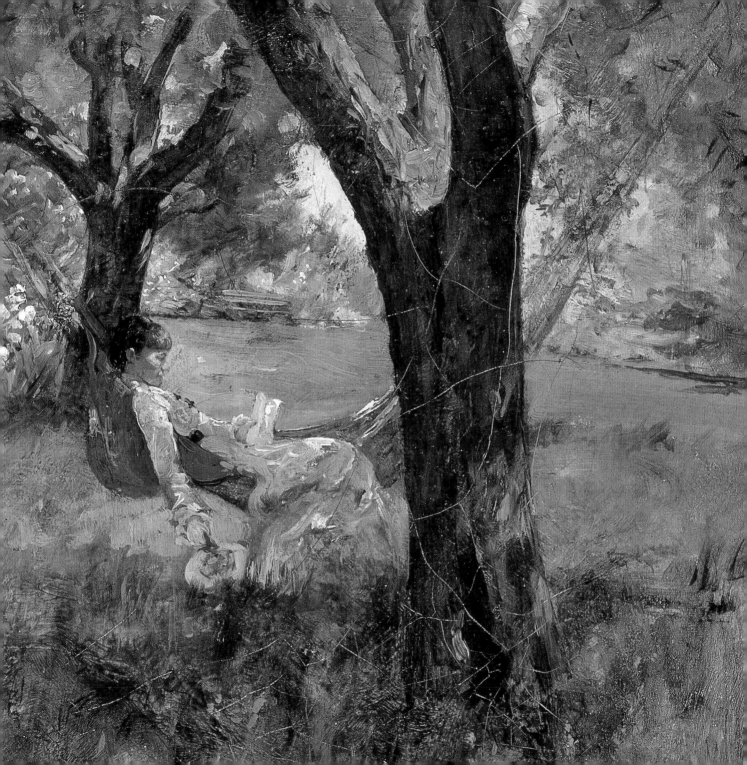

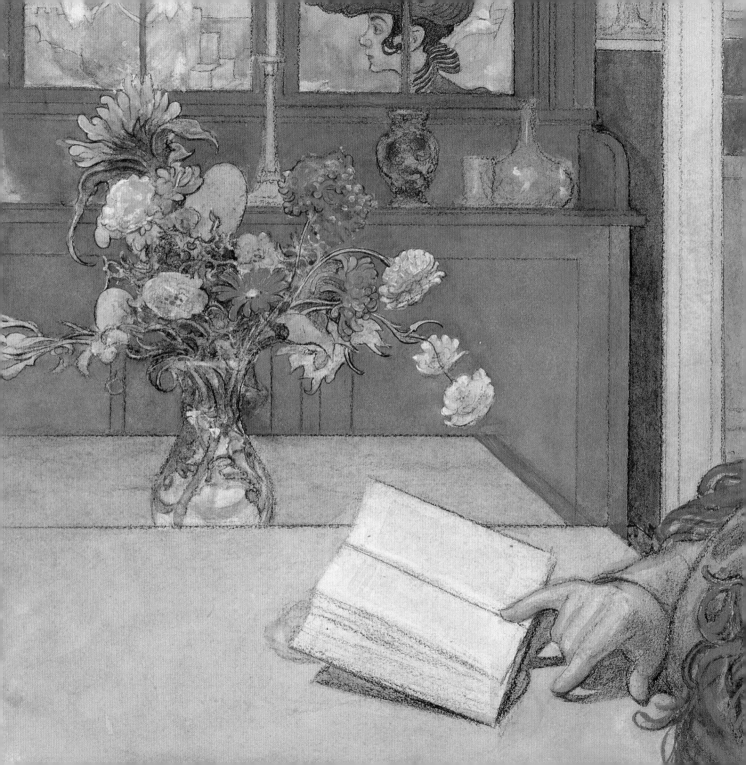

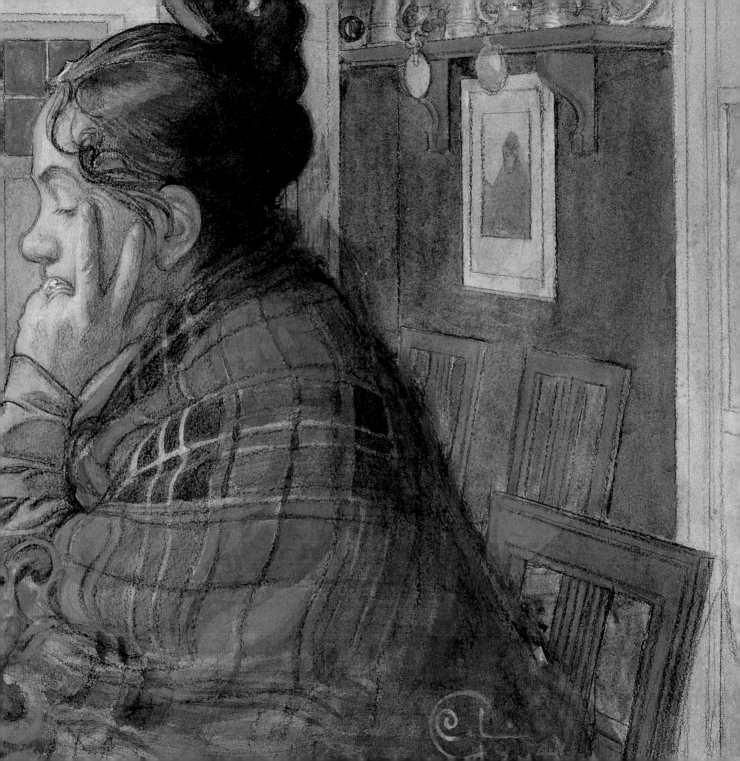

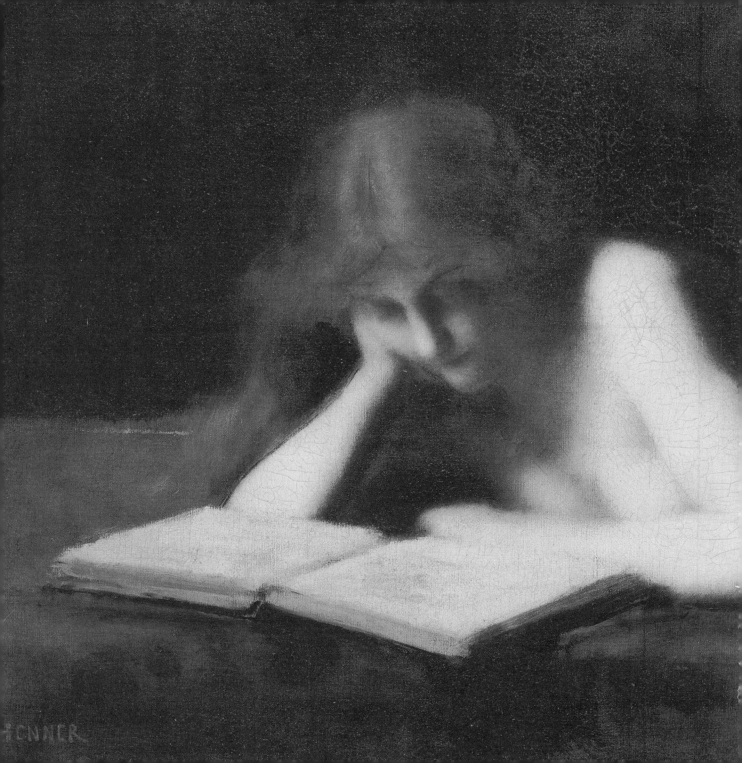